The FARMER

Created by

Mark Ludy

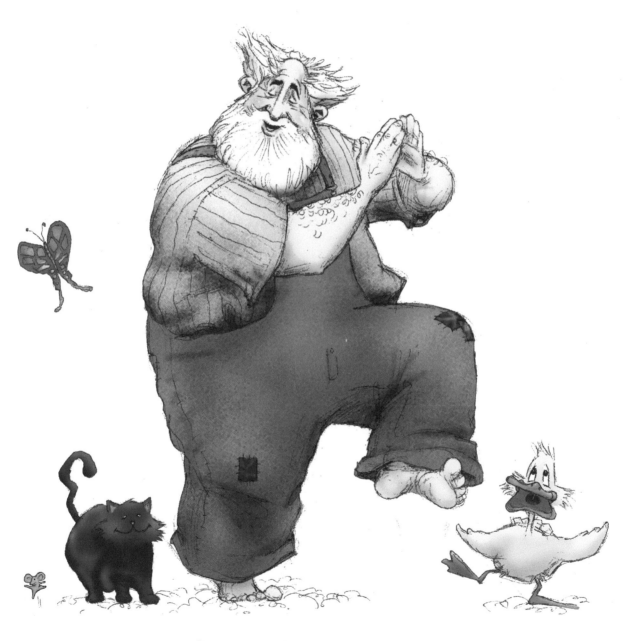

Scribble&Sons
GoodBookCo.com

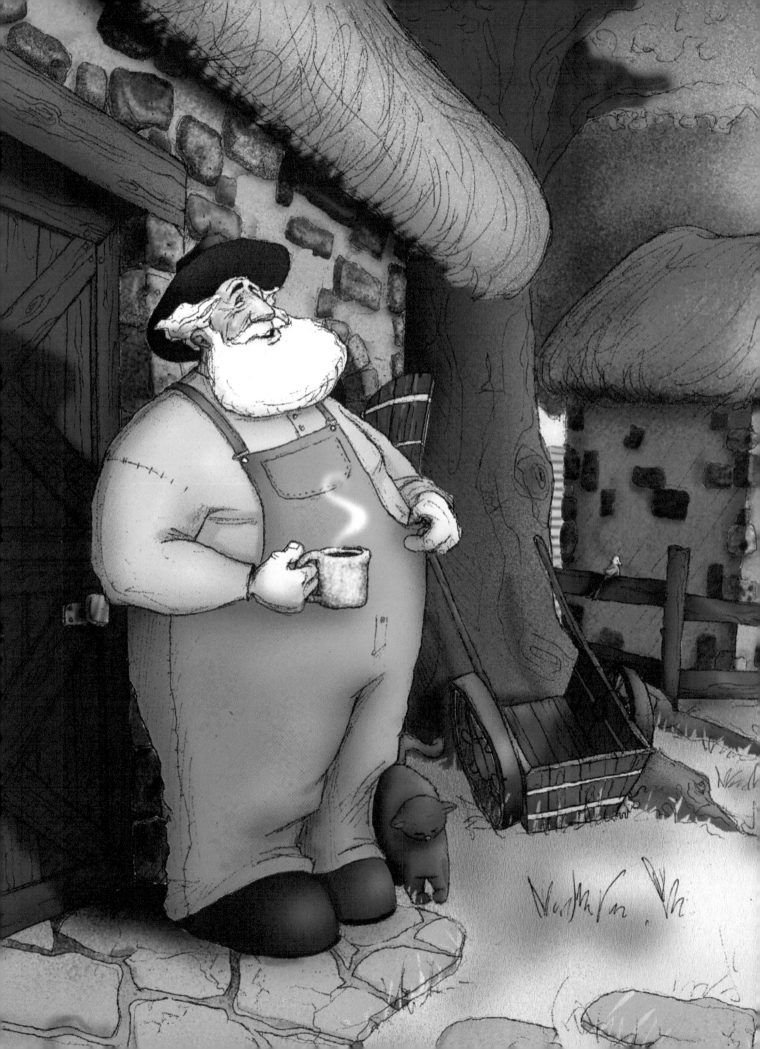

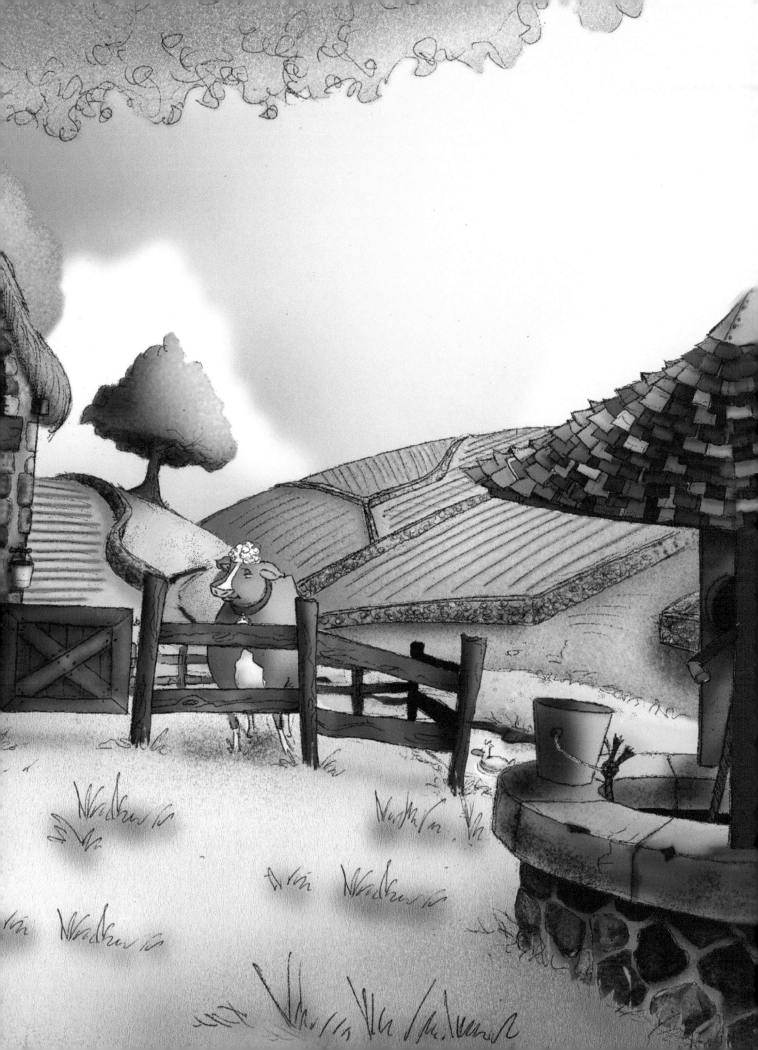

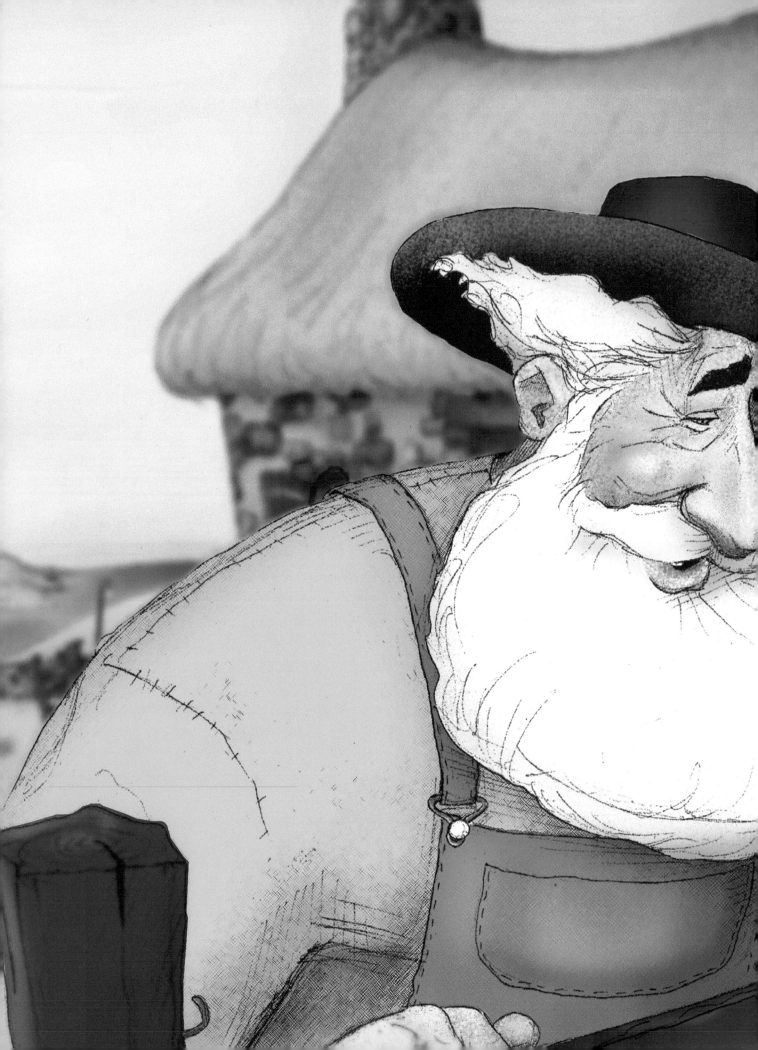

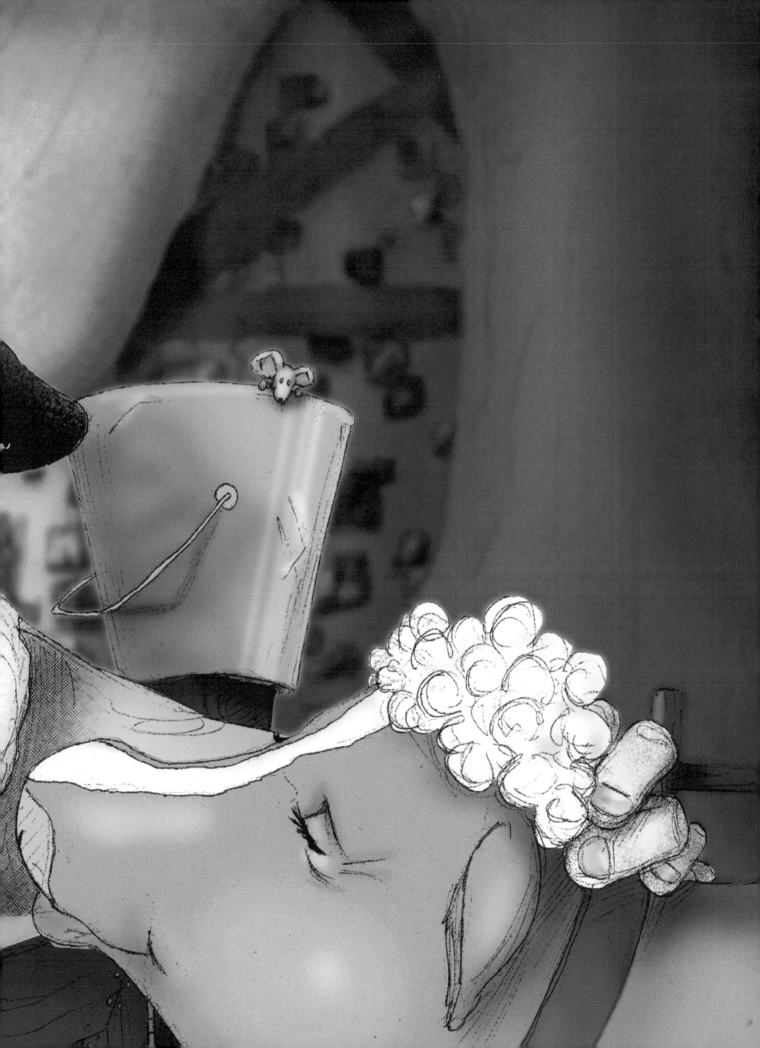

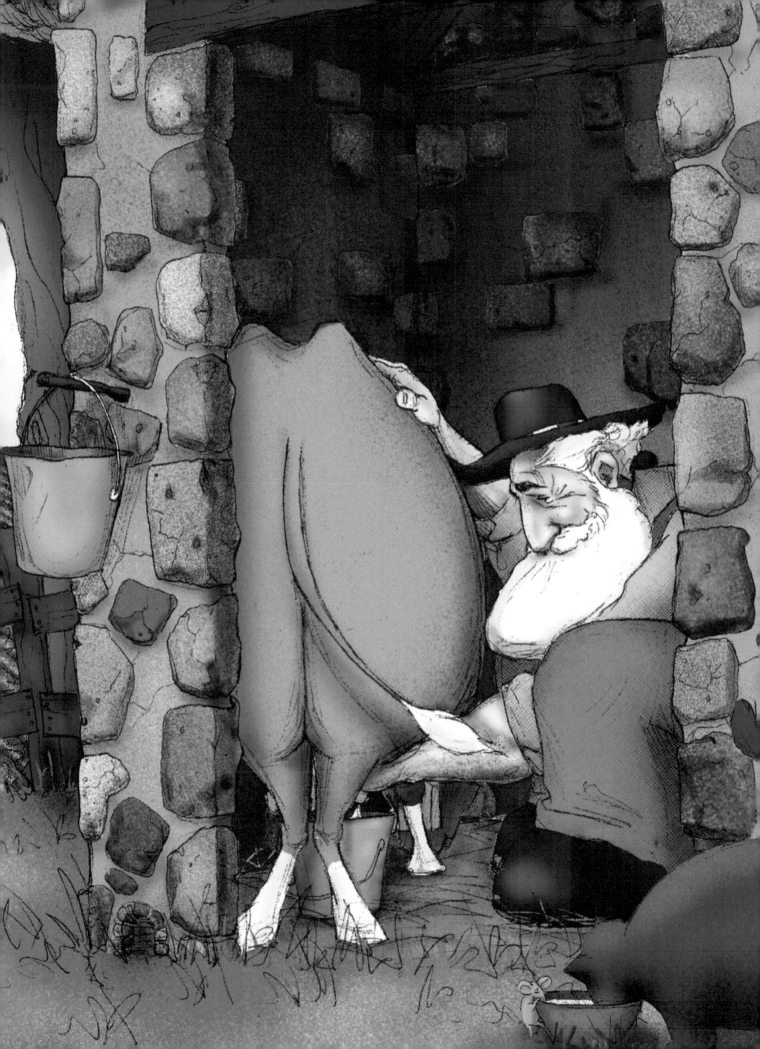

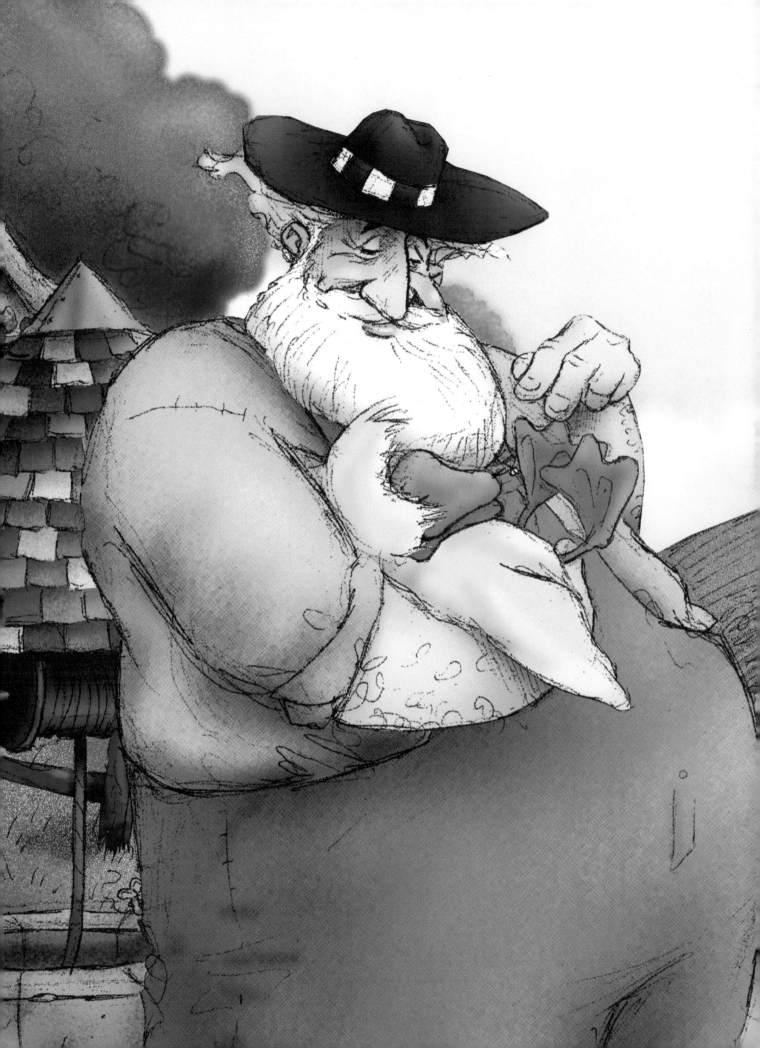

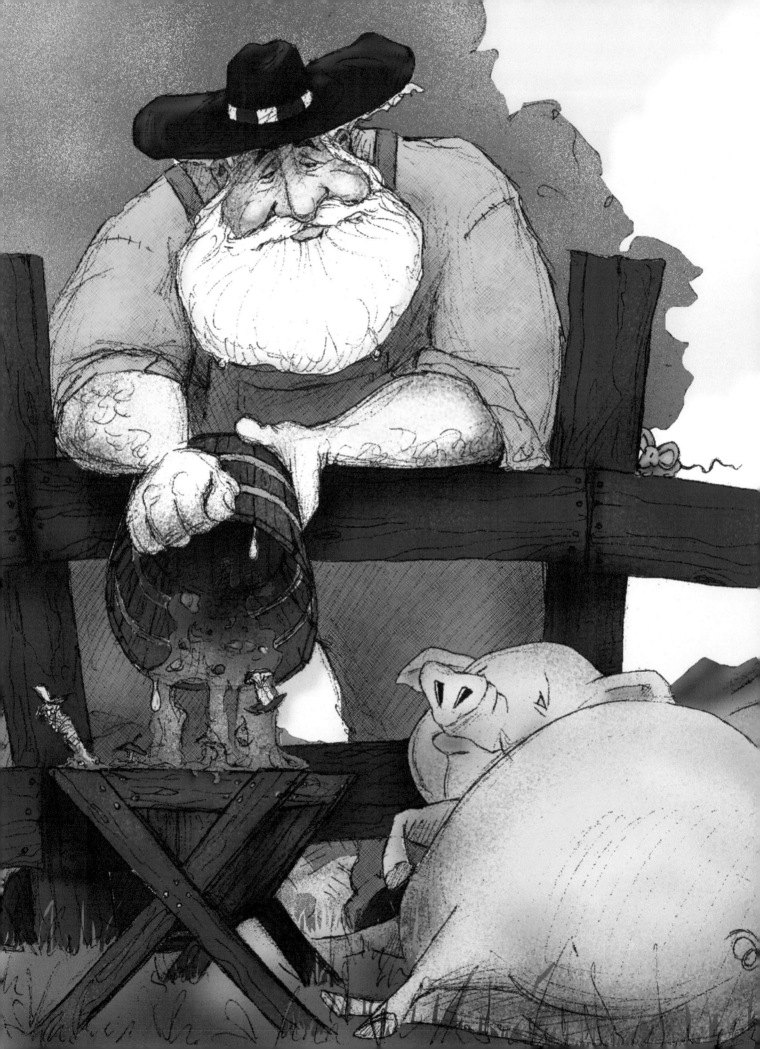

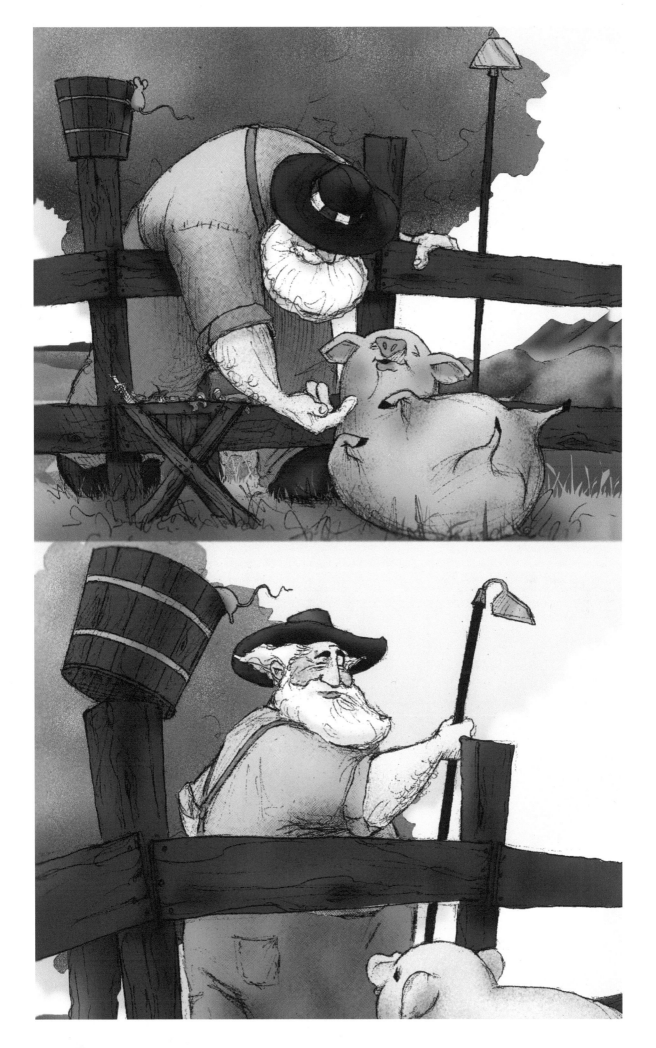

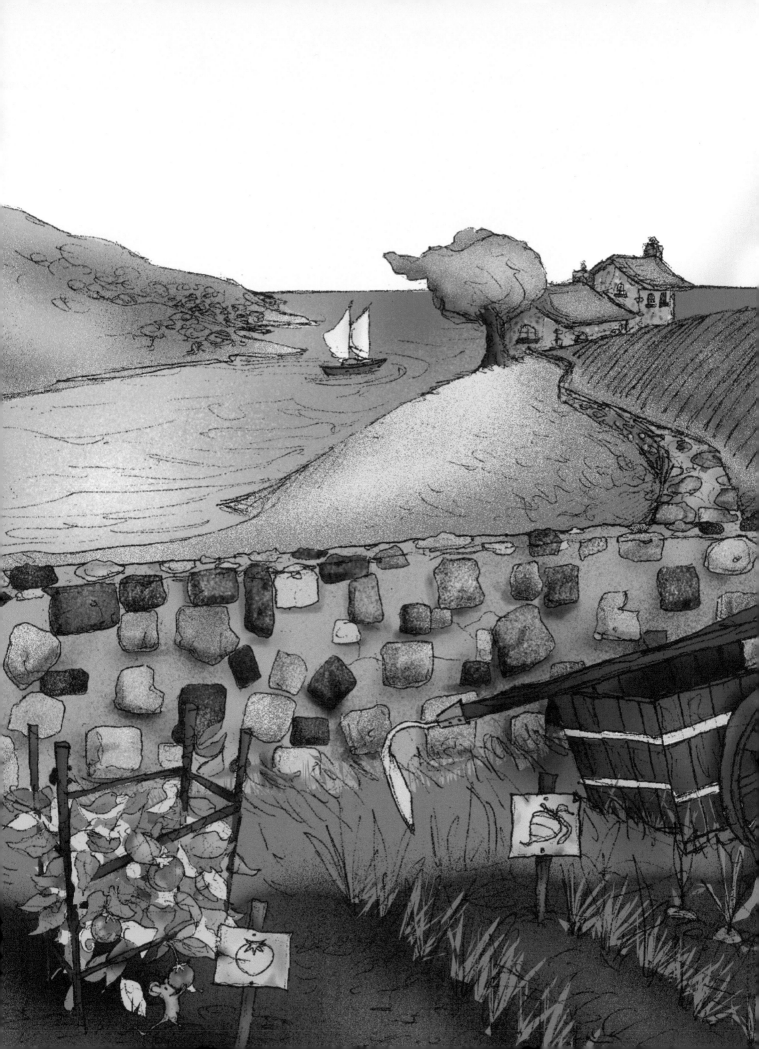

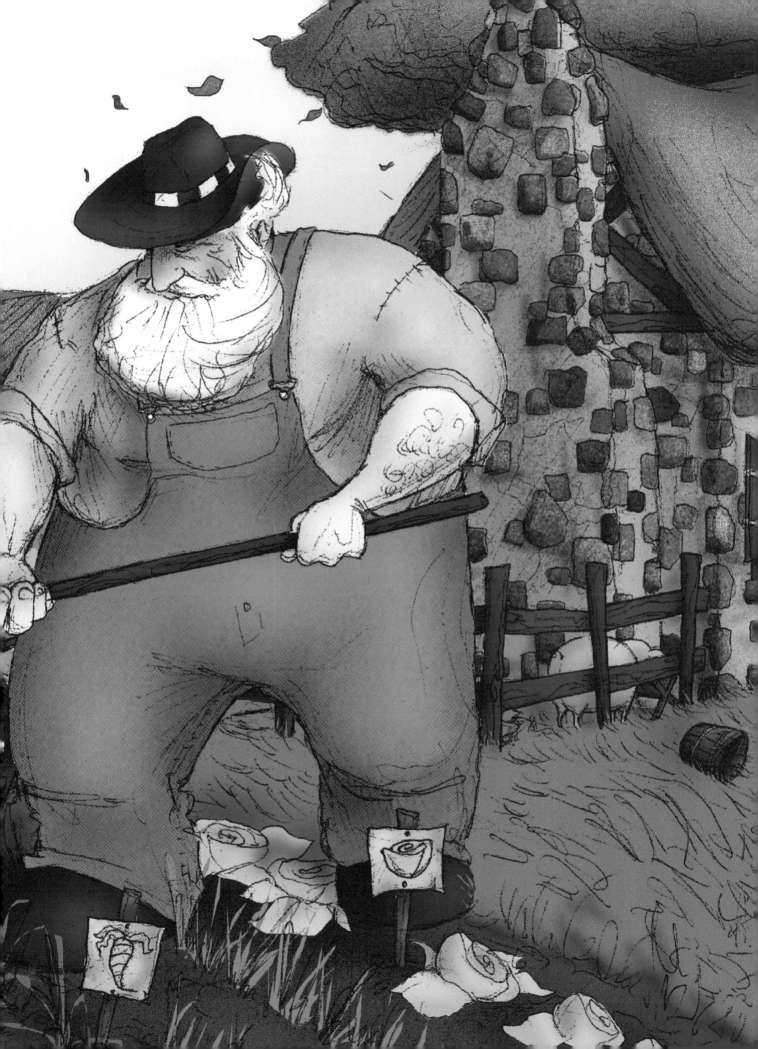

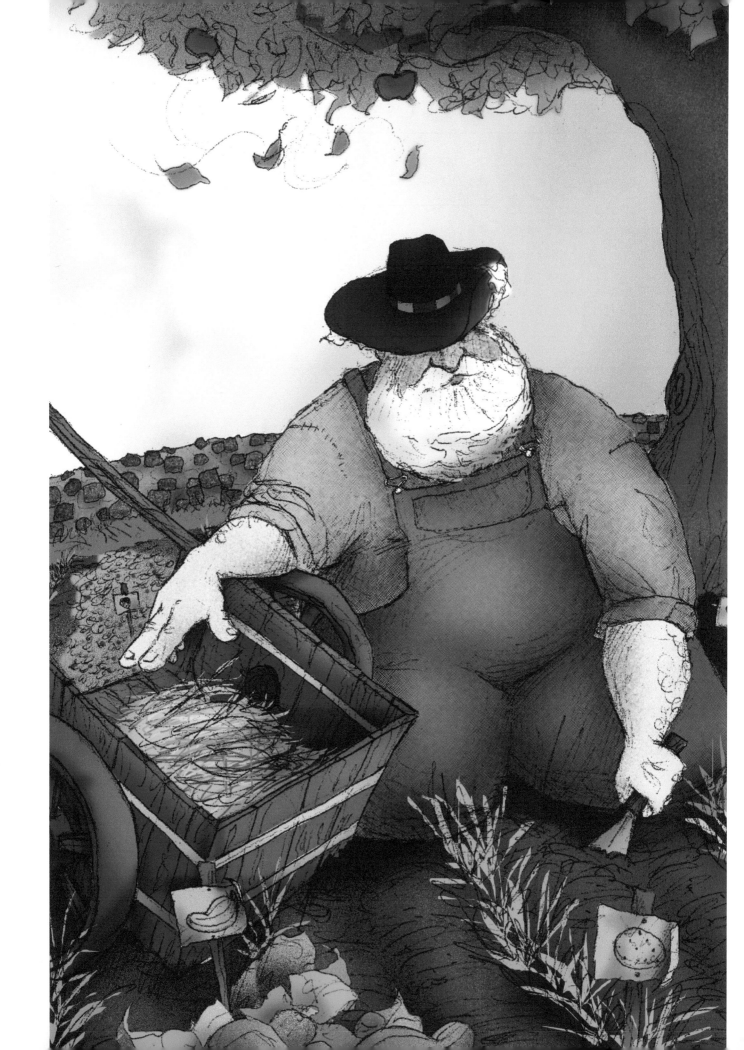

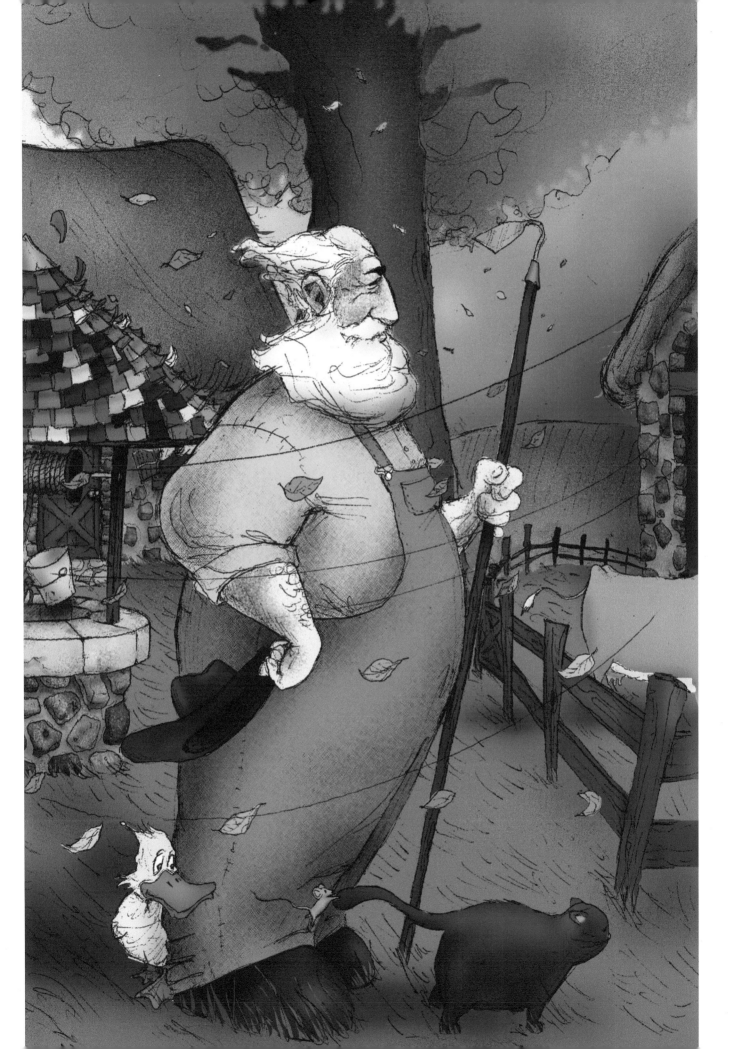

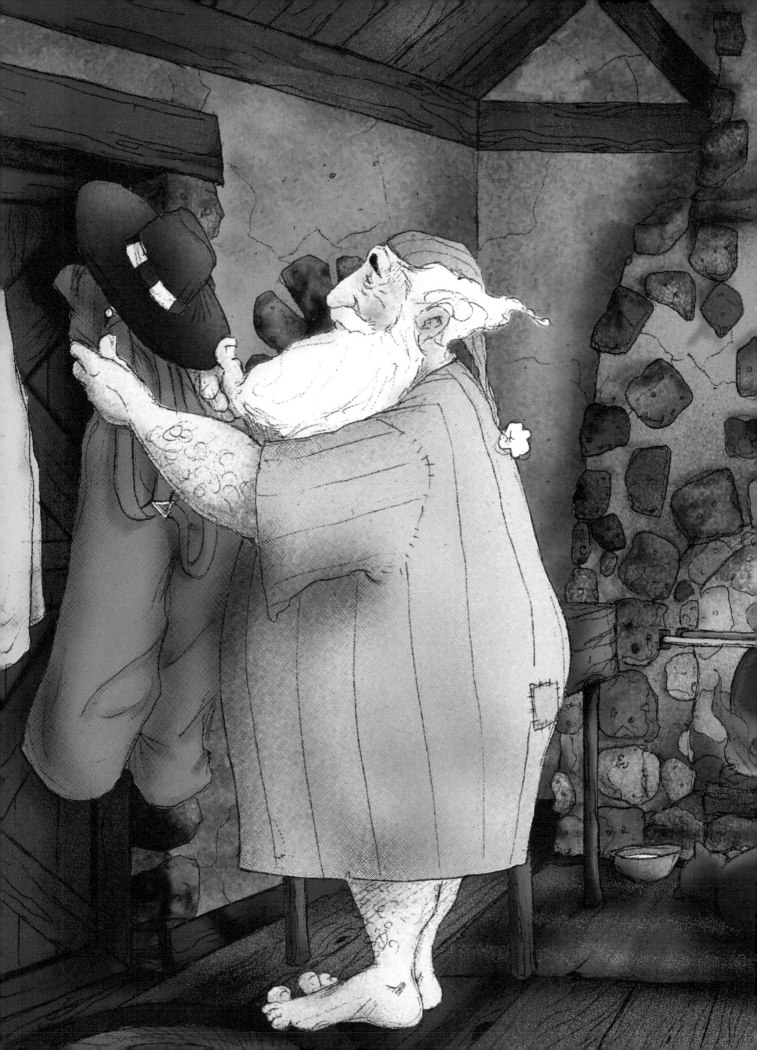

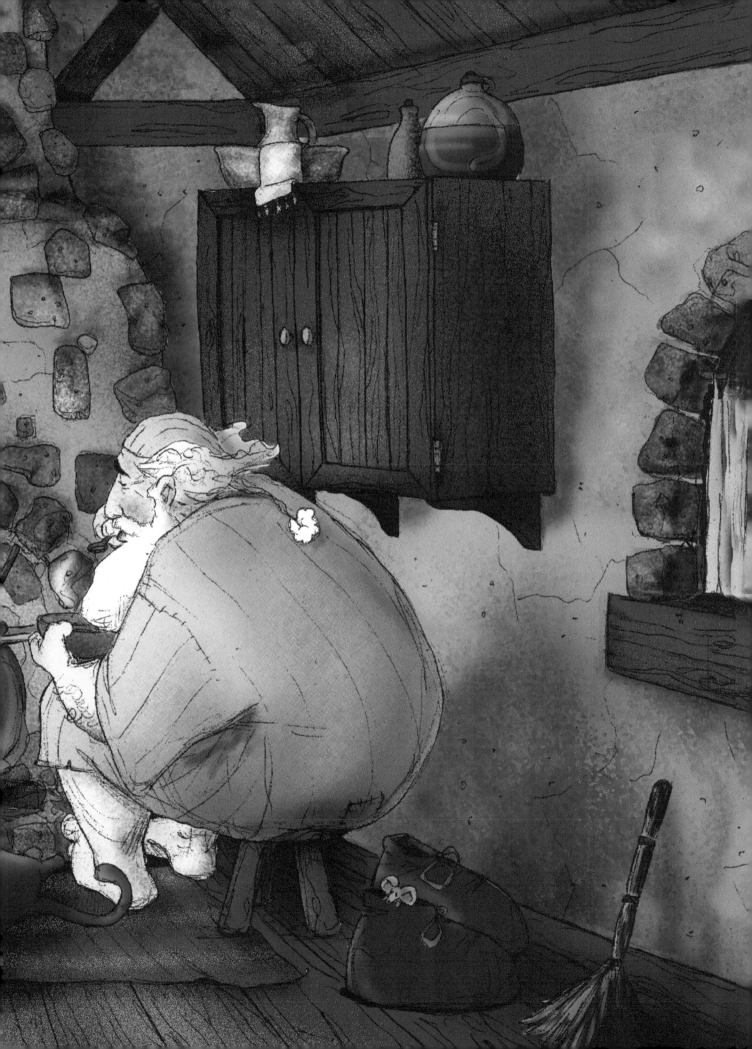

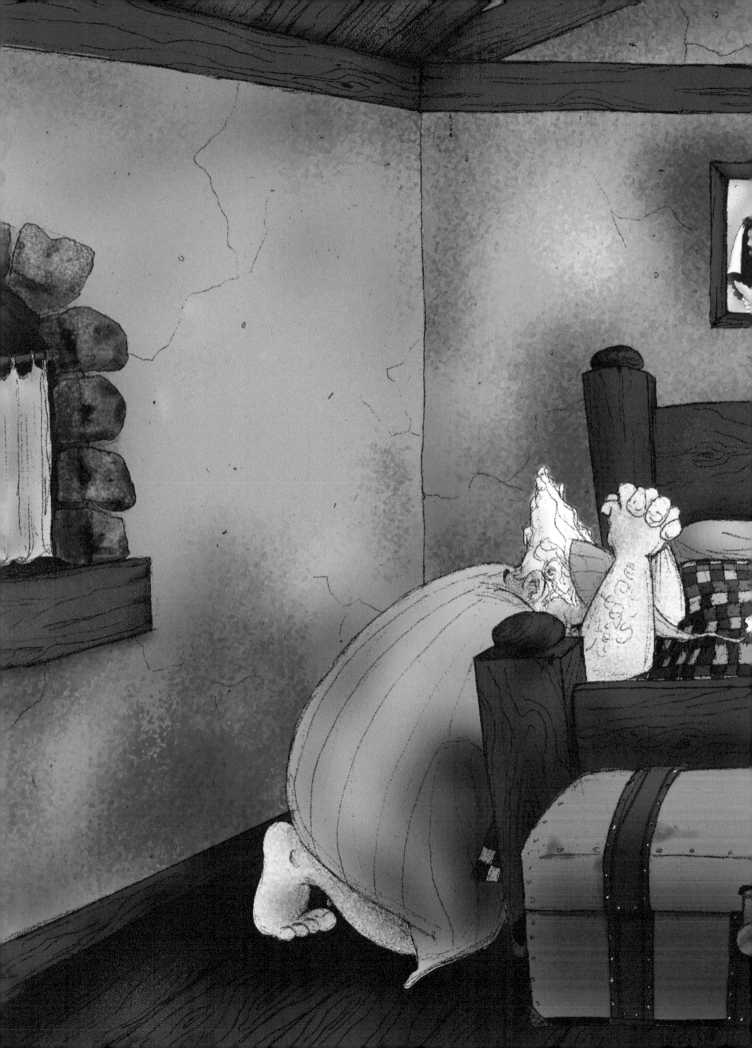

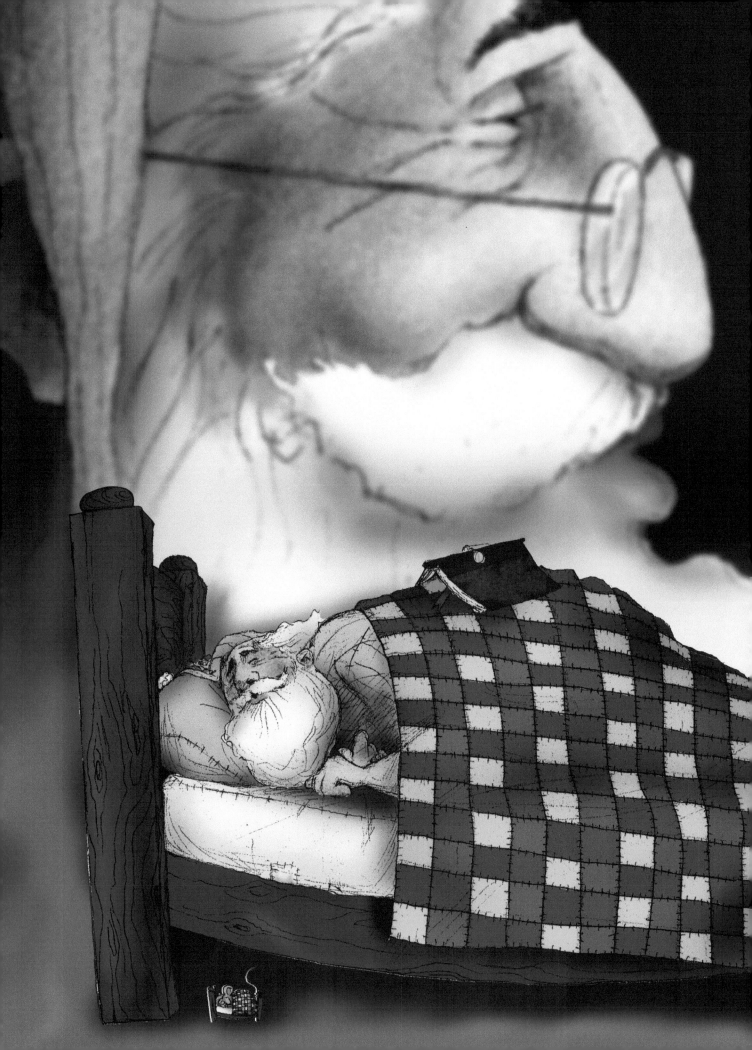

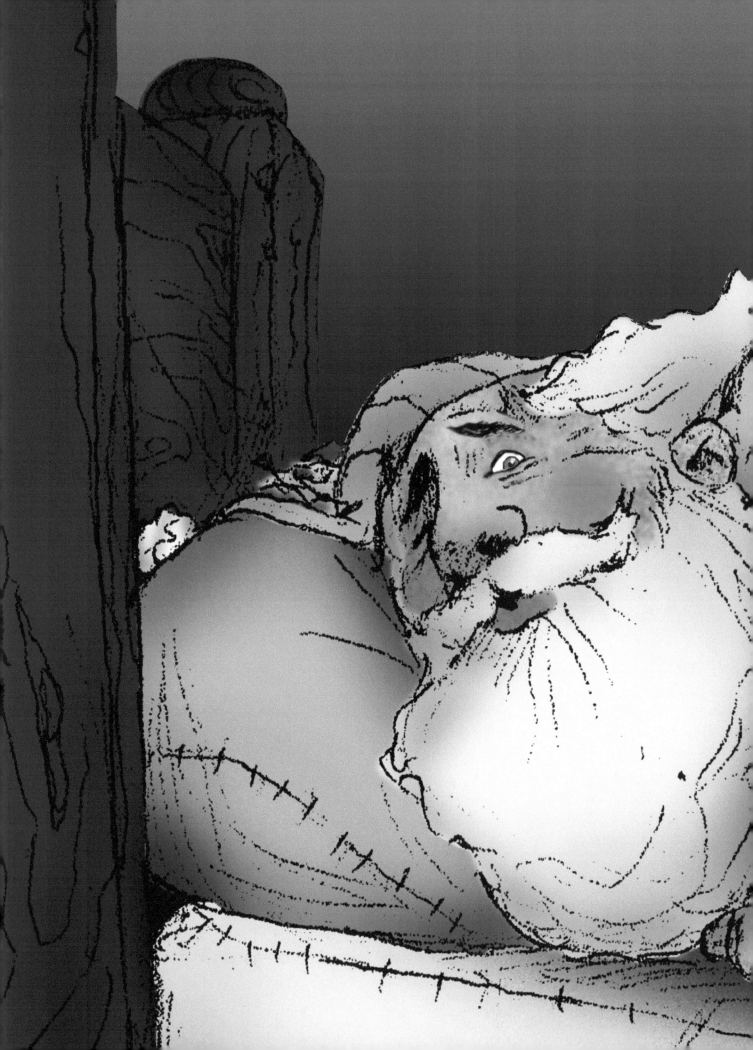

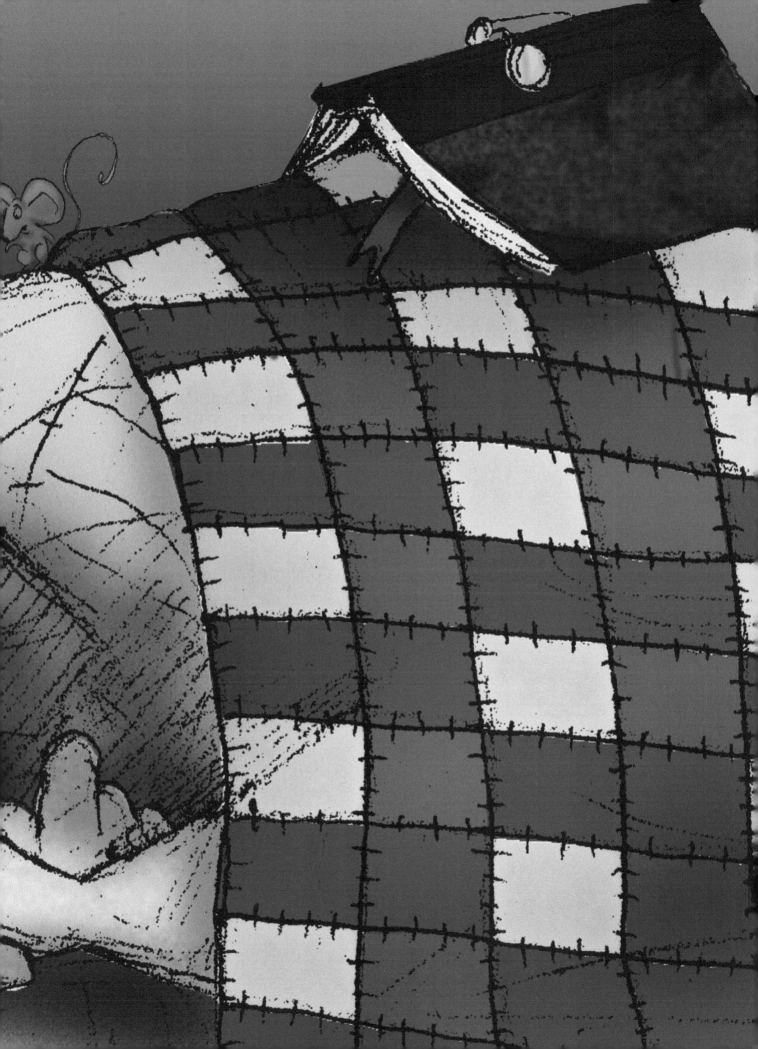

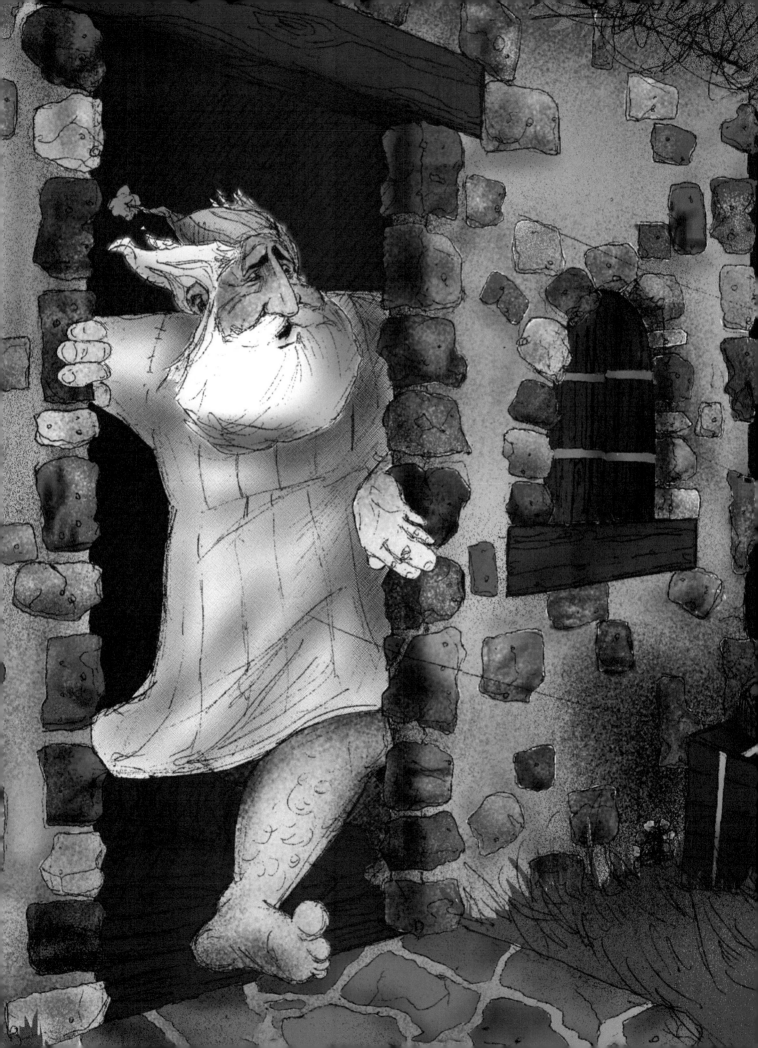

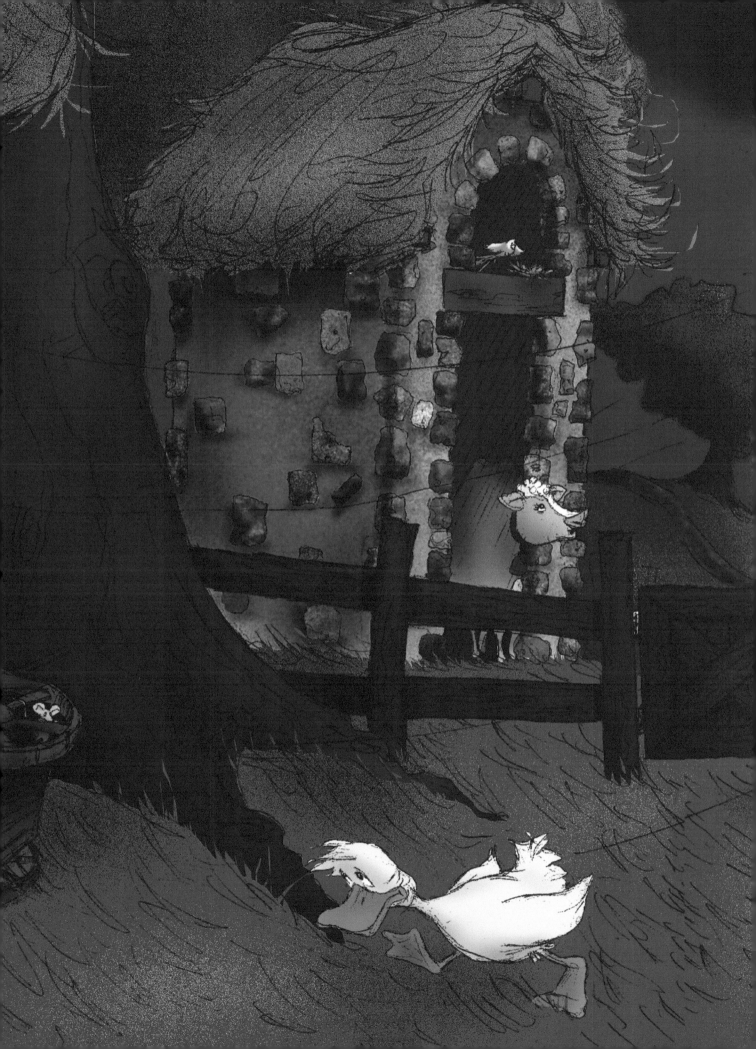

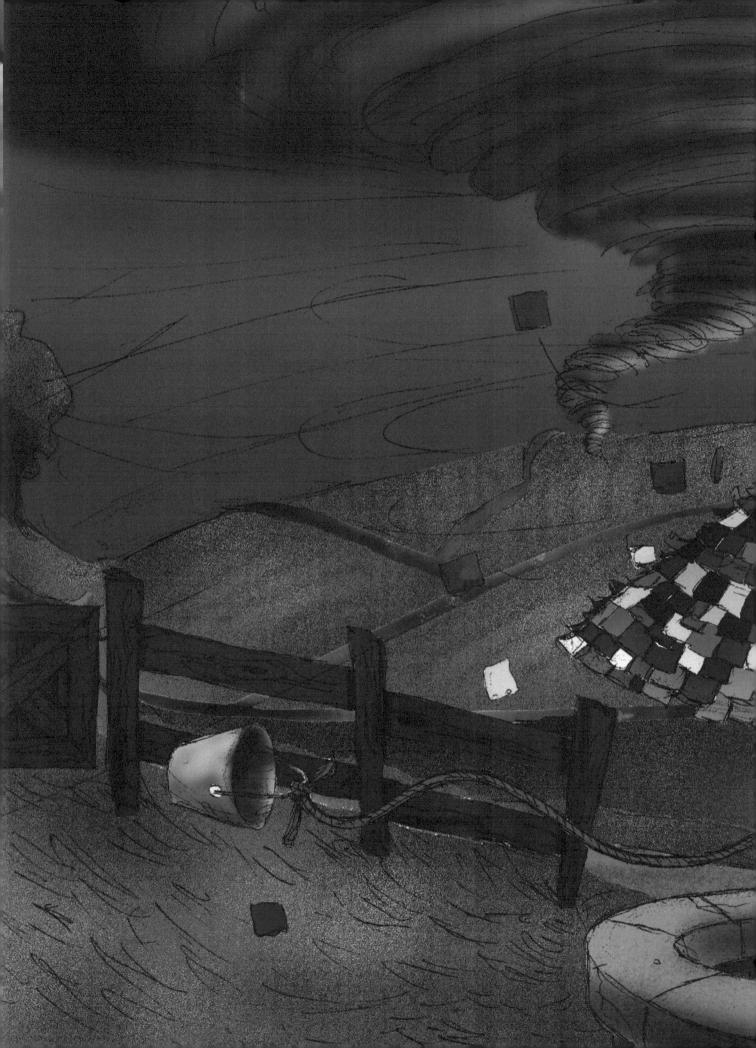

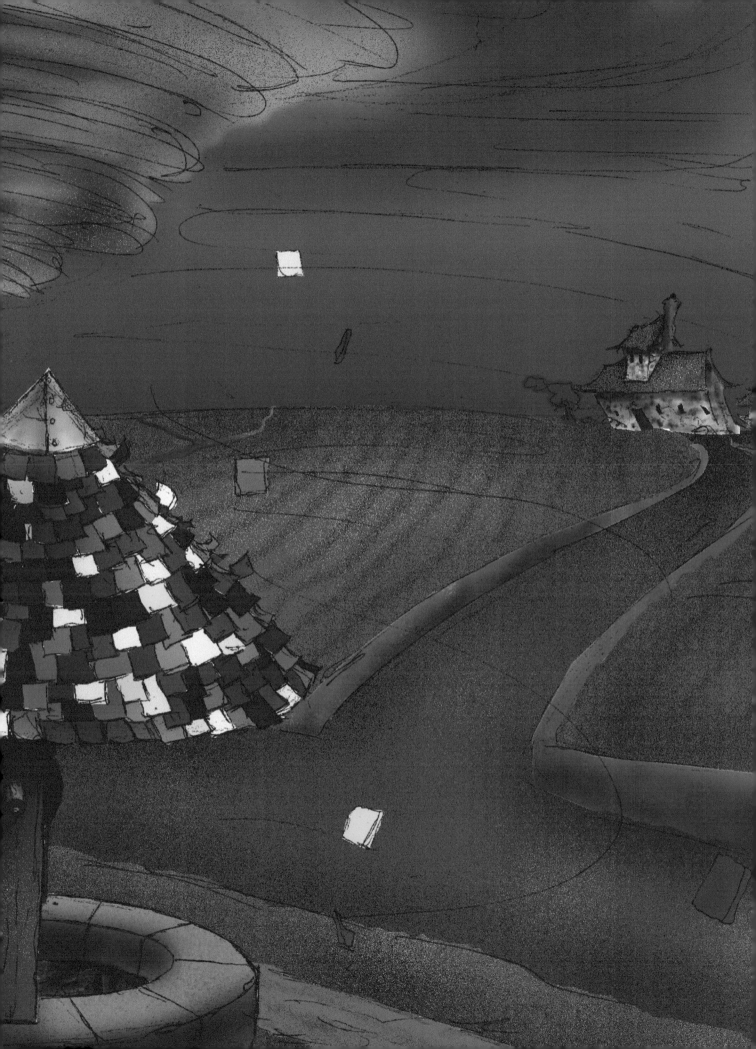

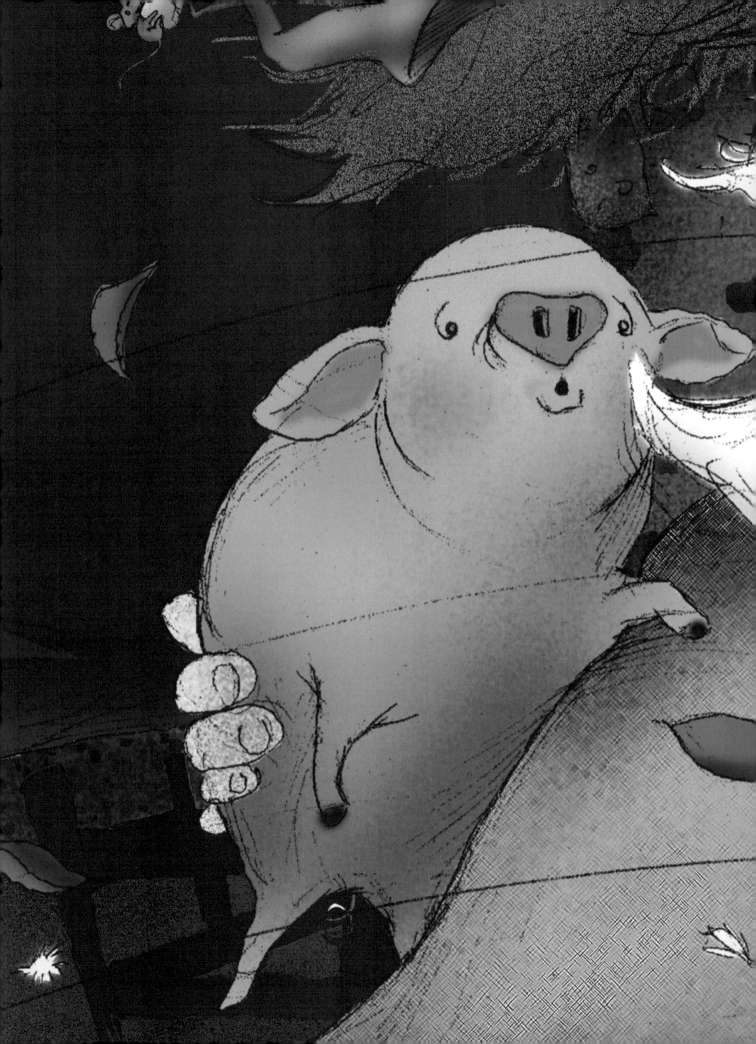

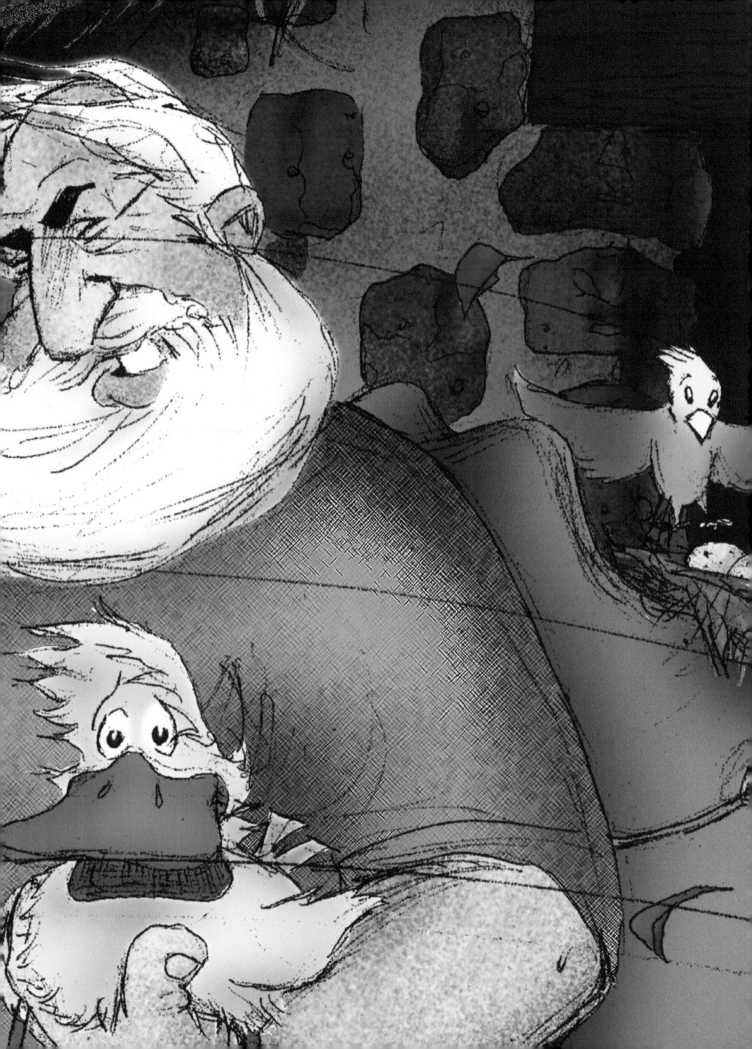

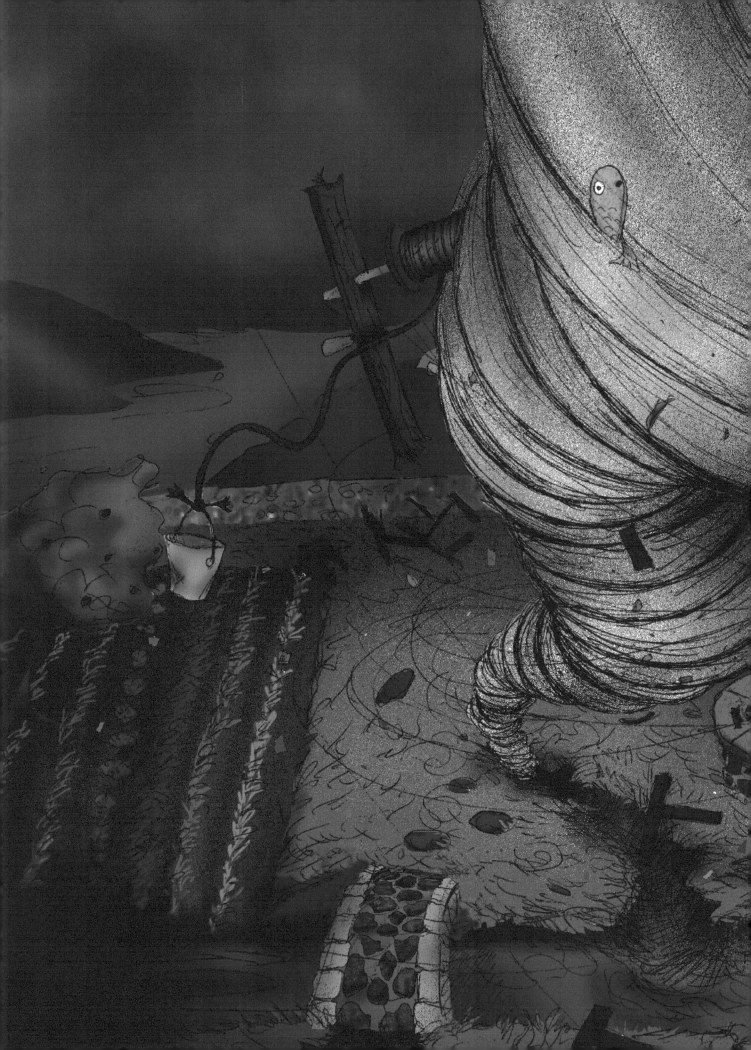

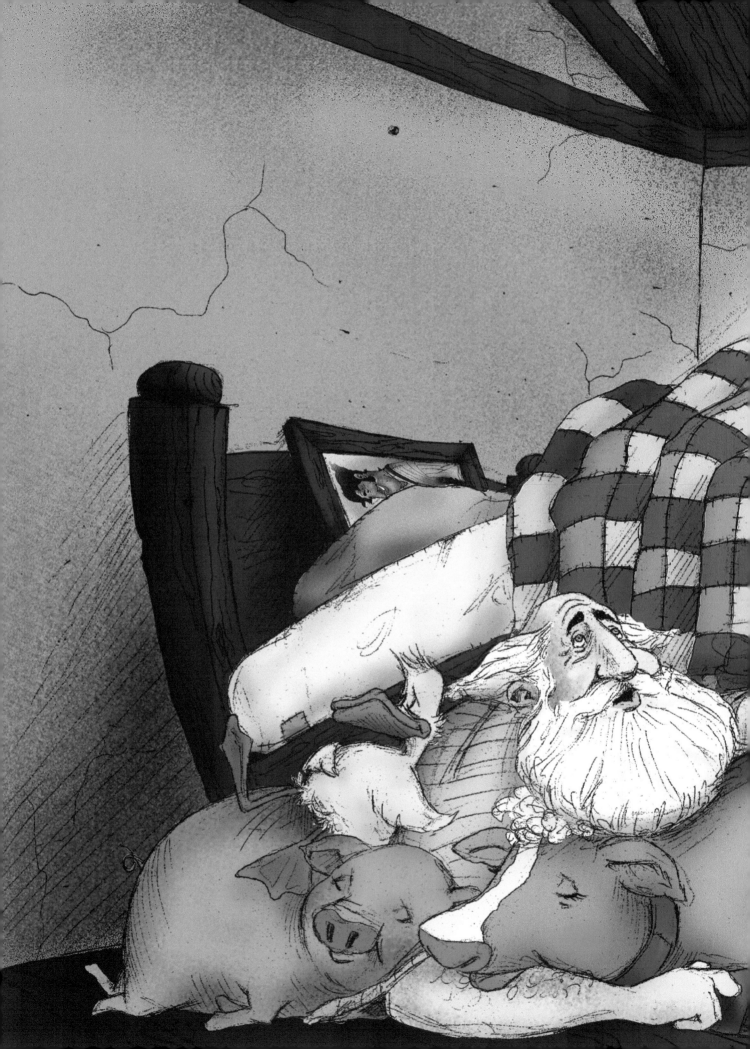

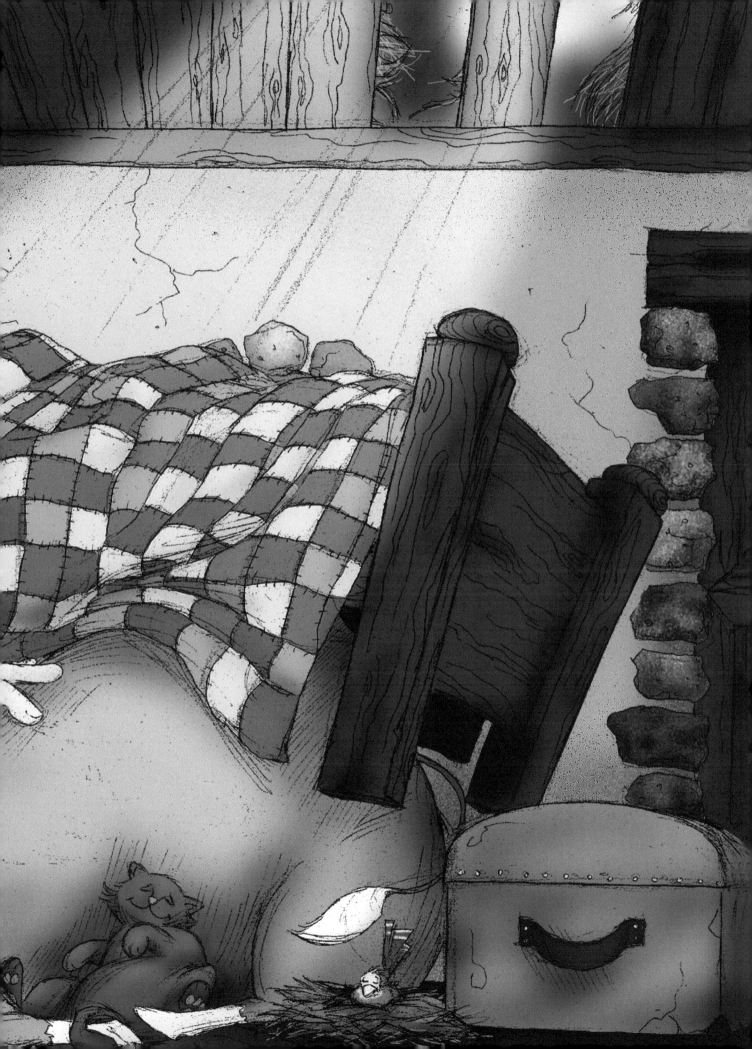

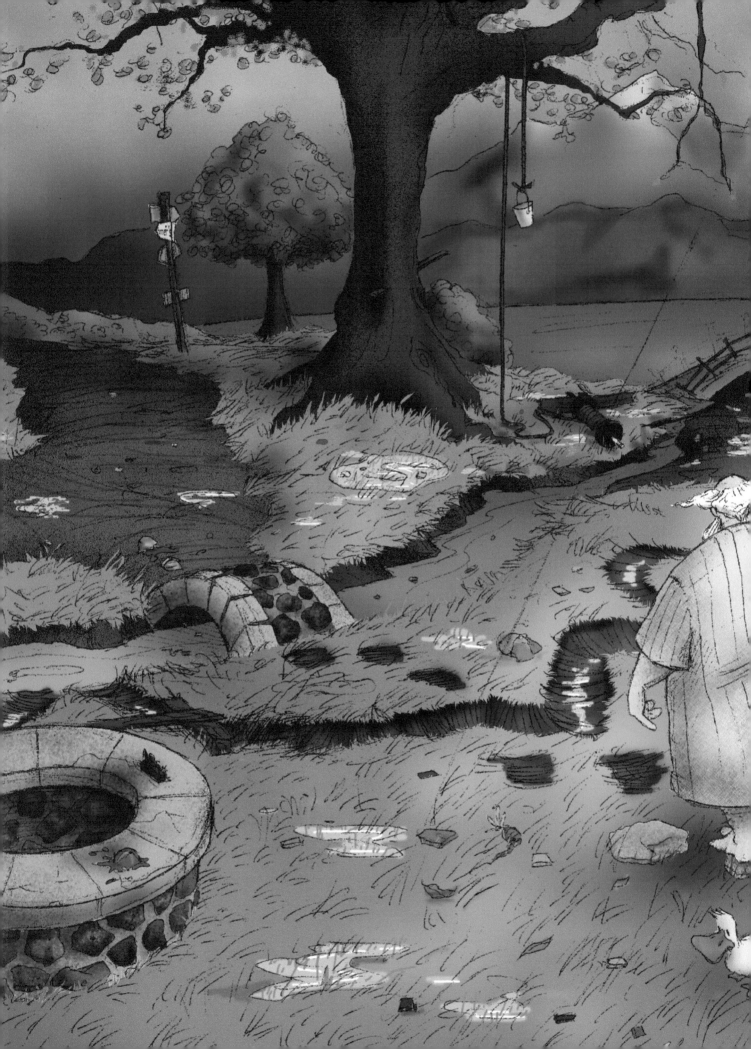

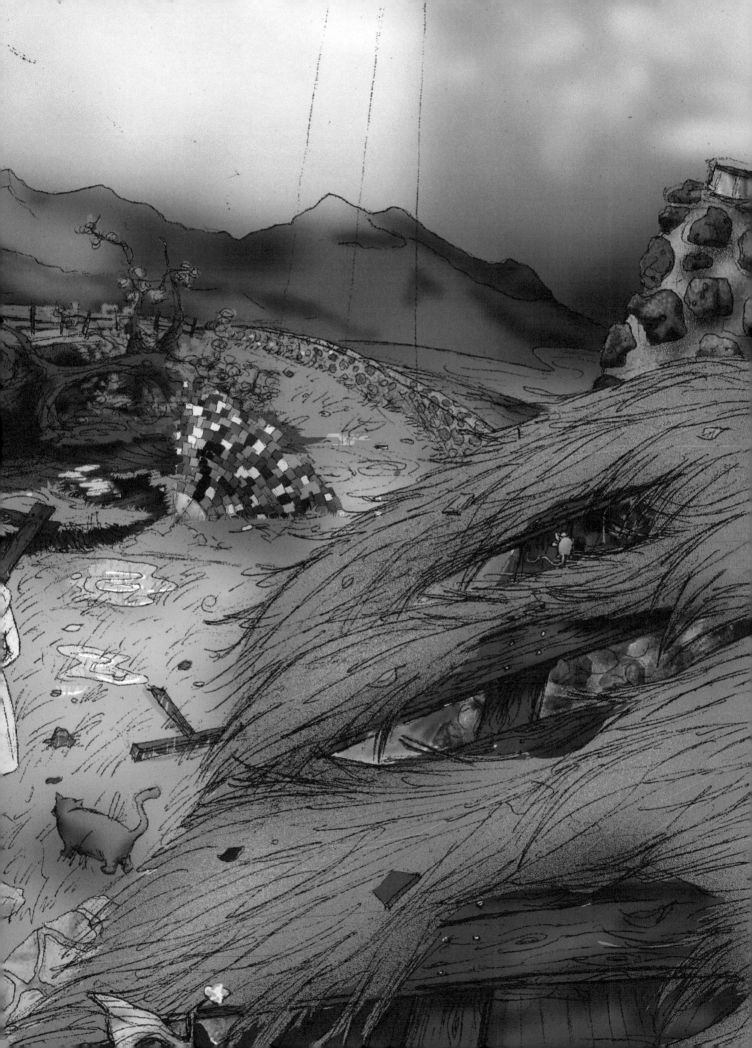

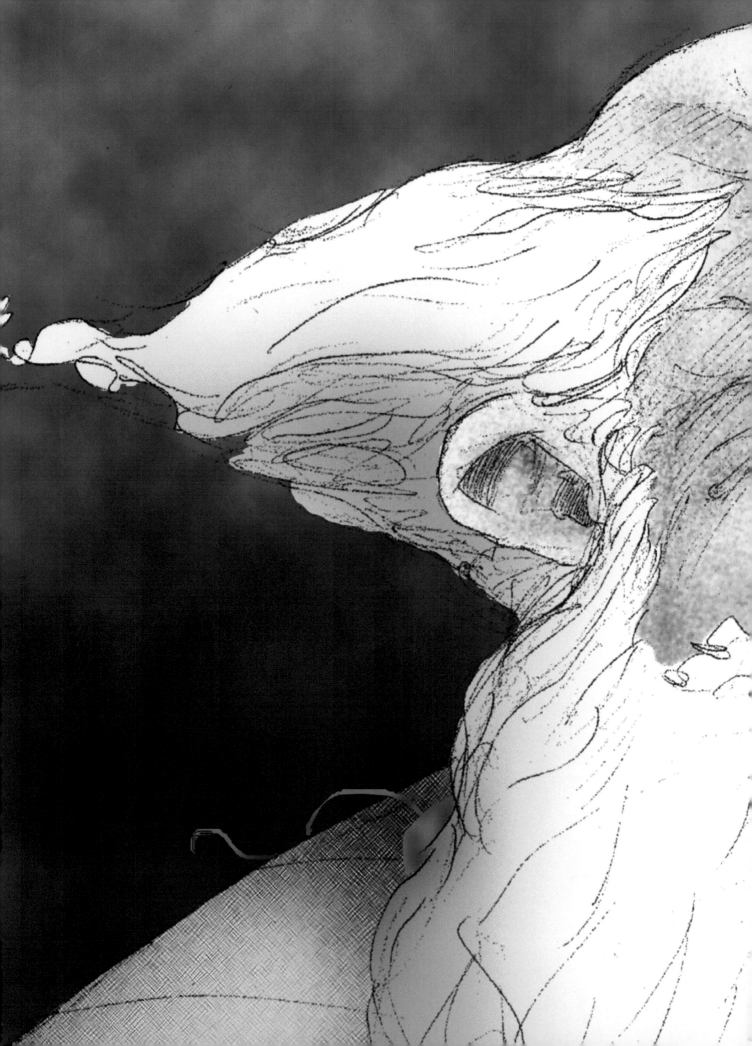

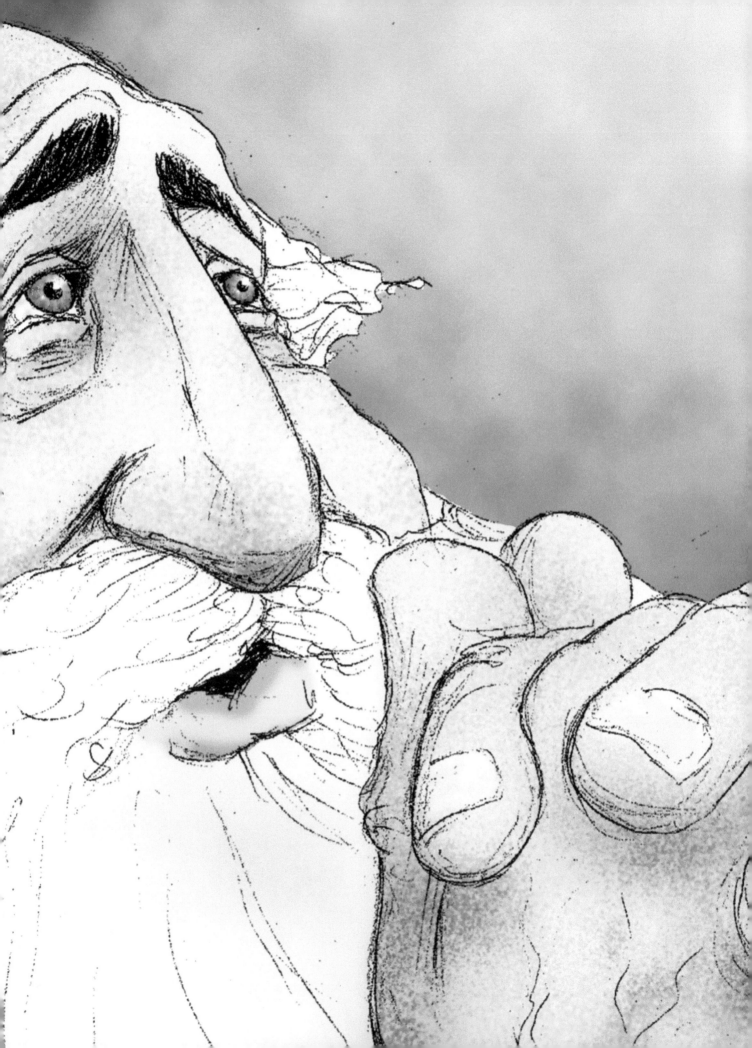

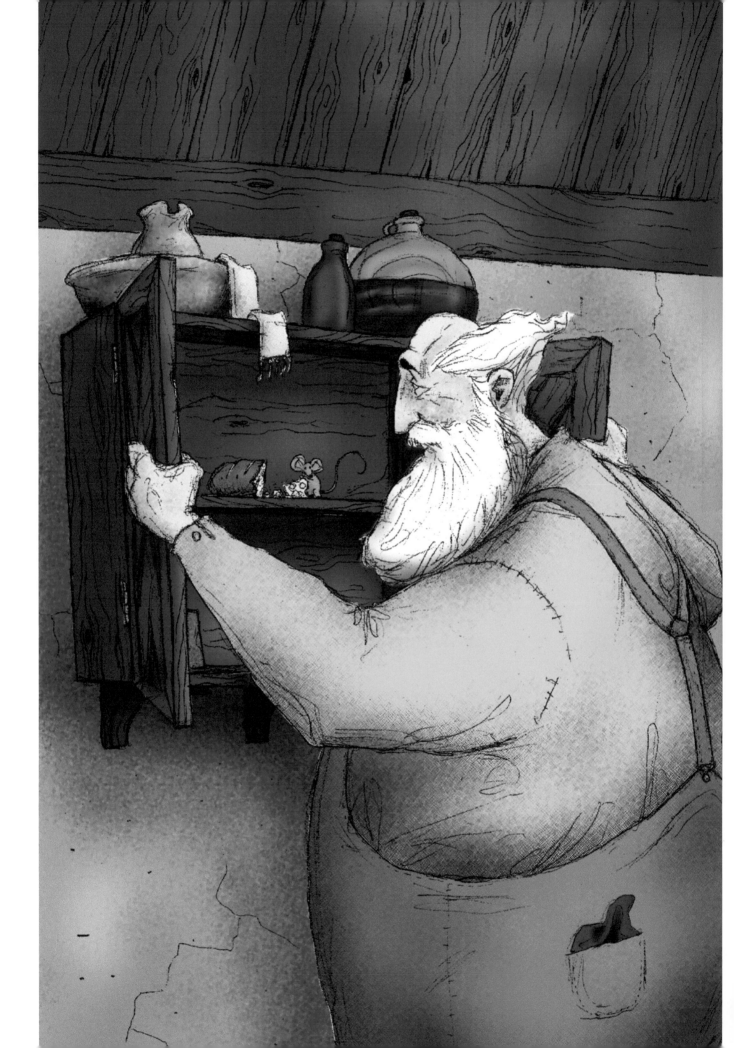

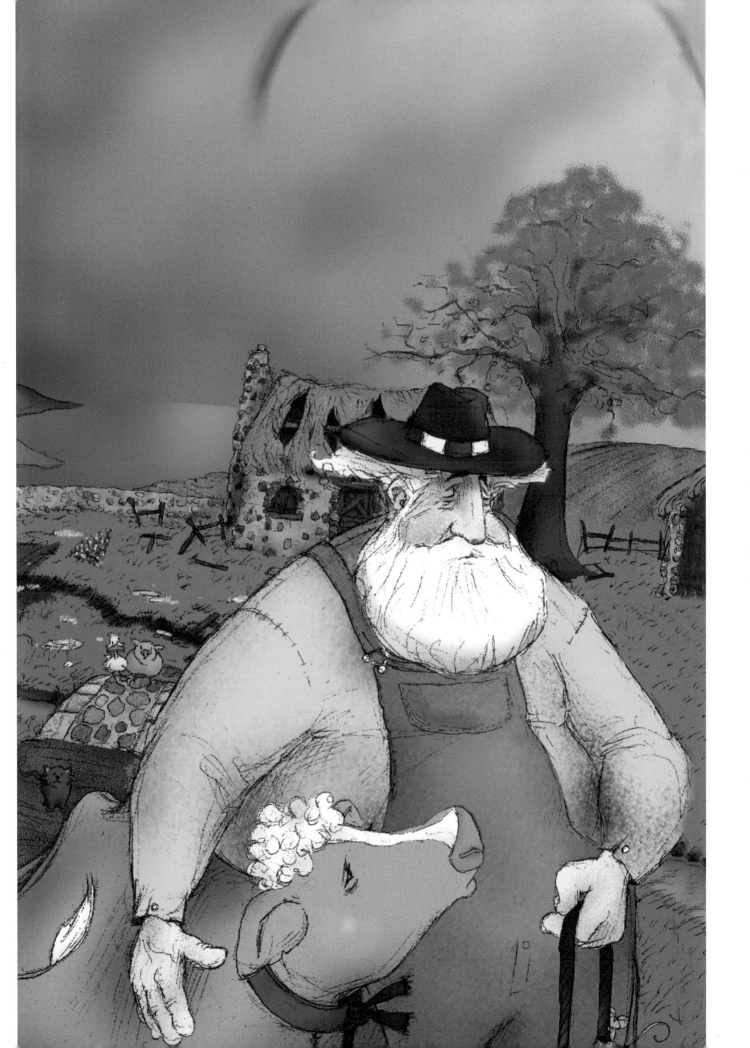

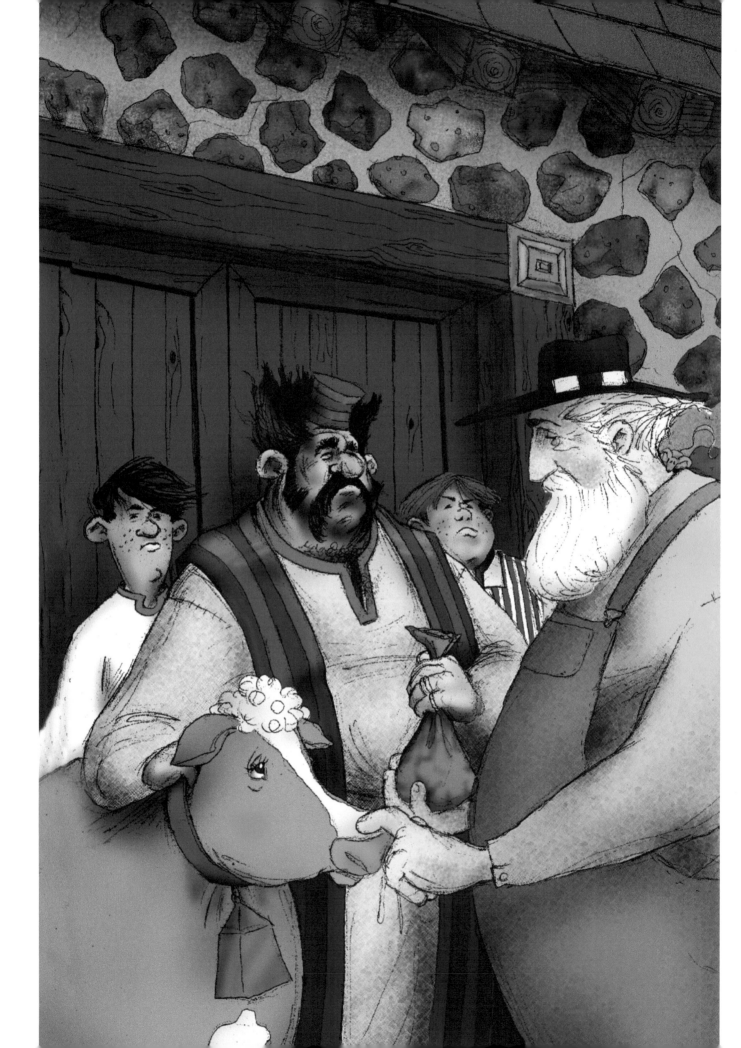

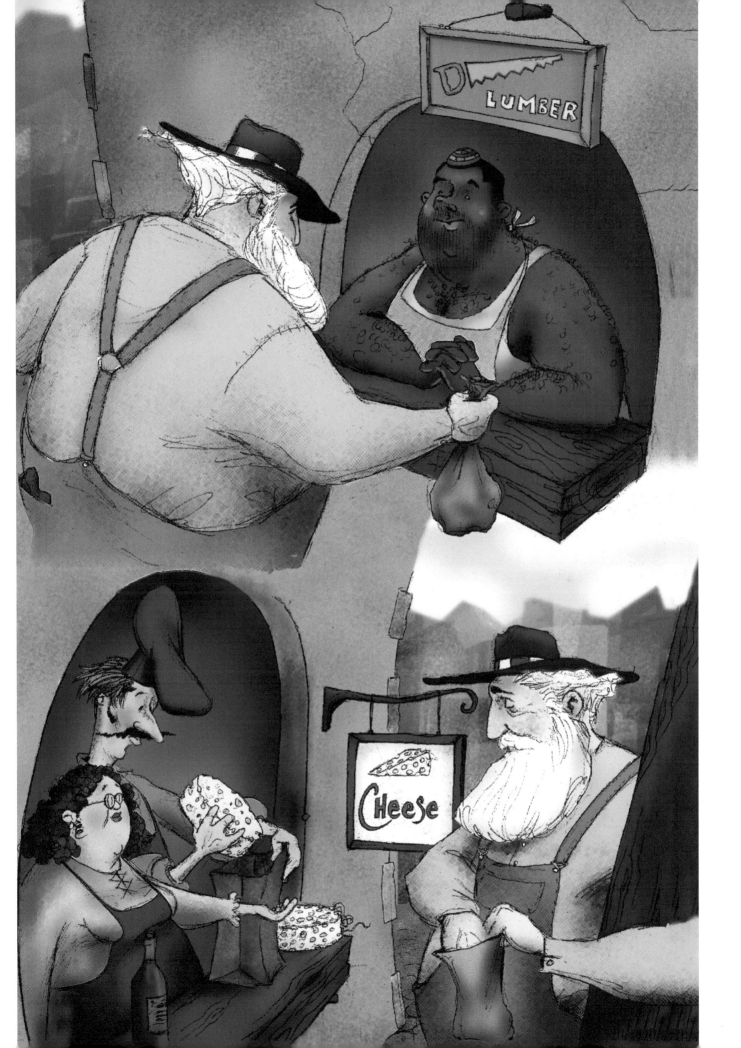

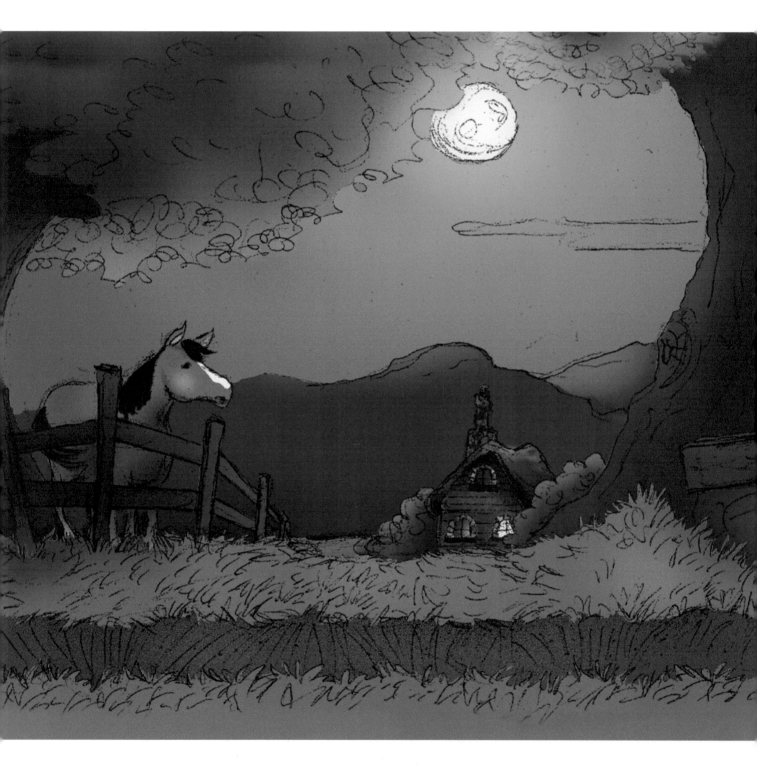

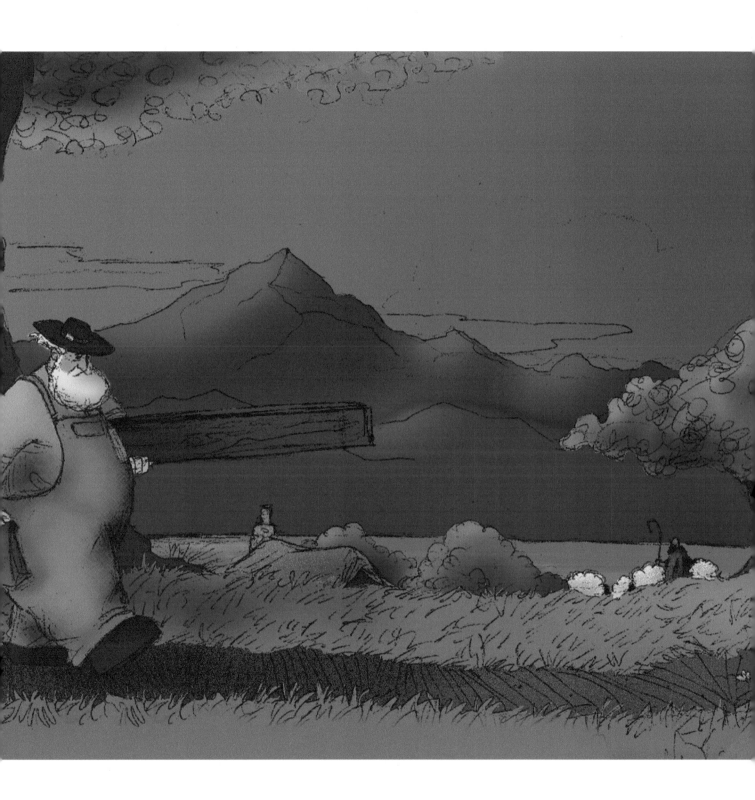

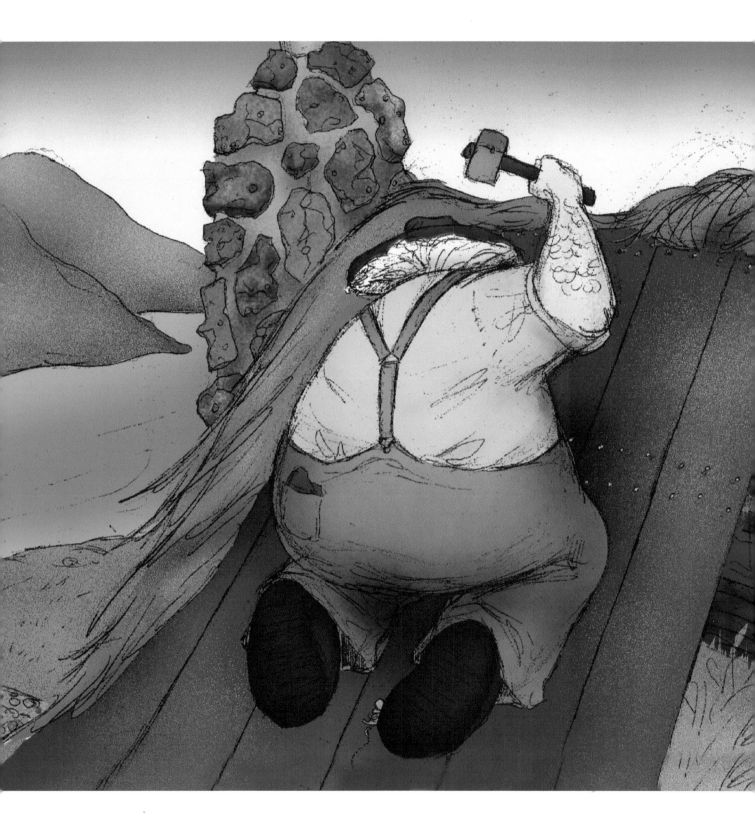

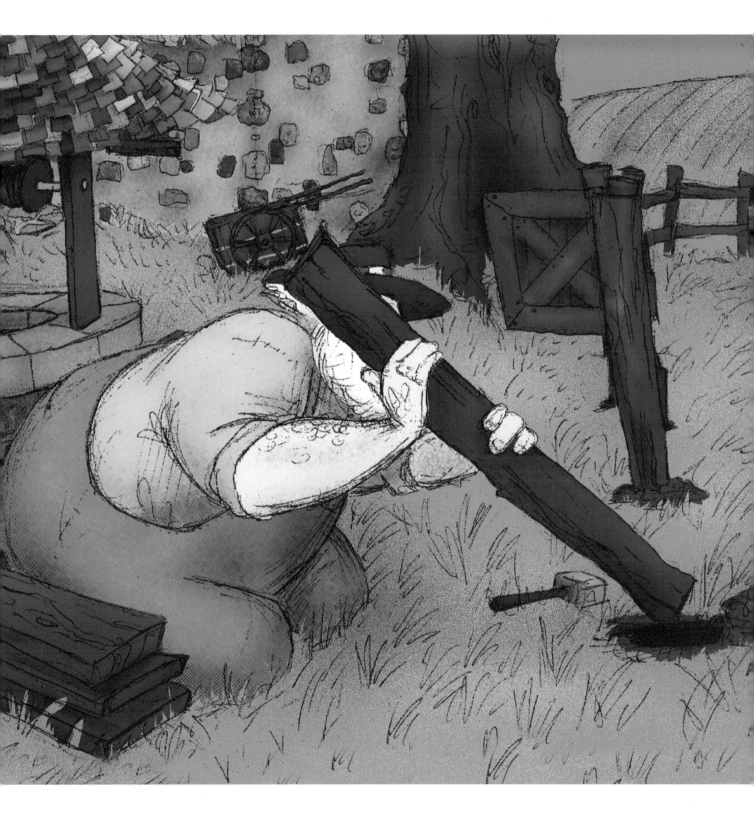

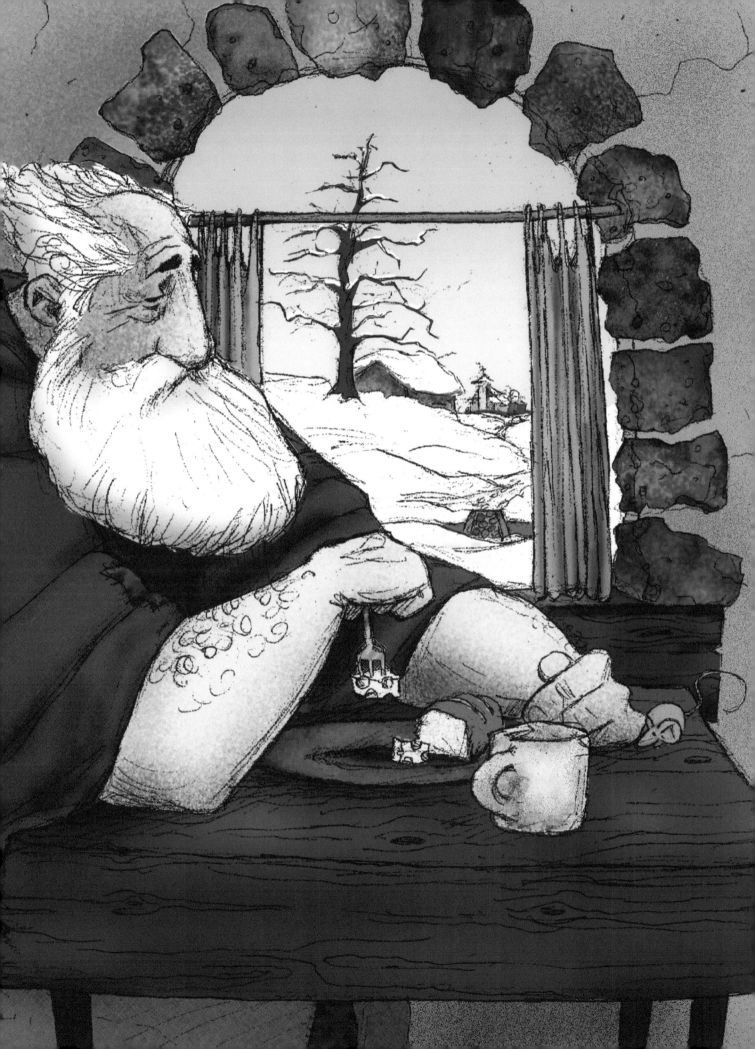

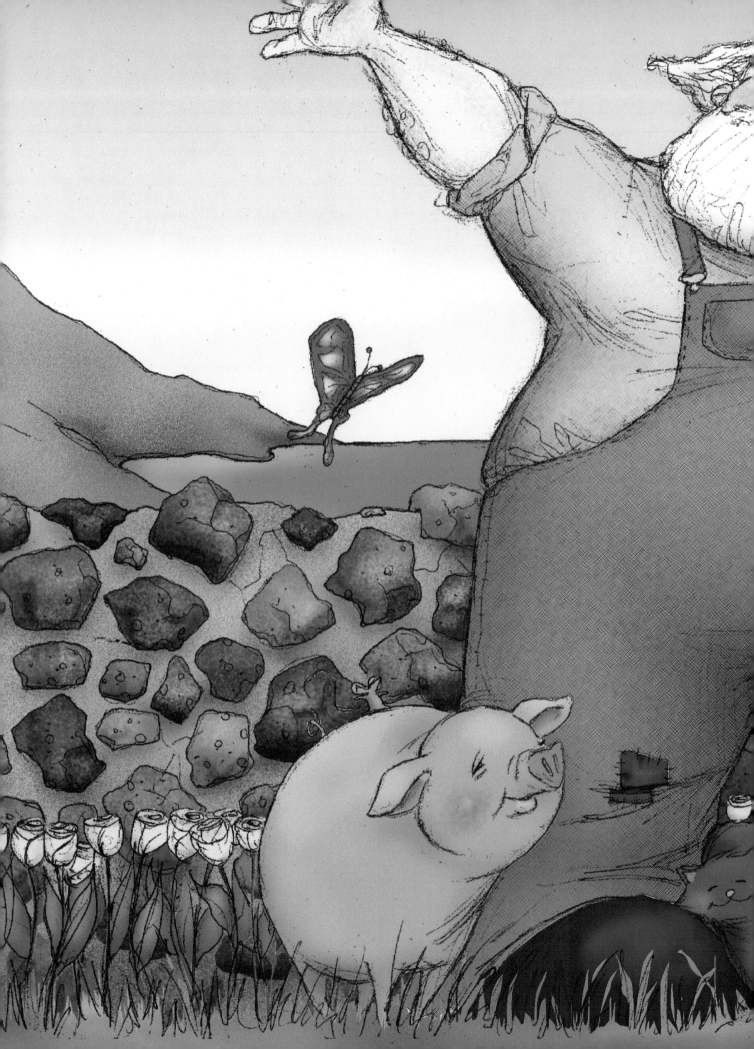

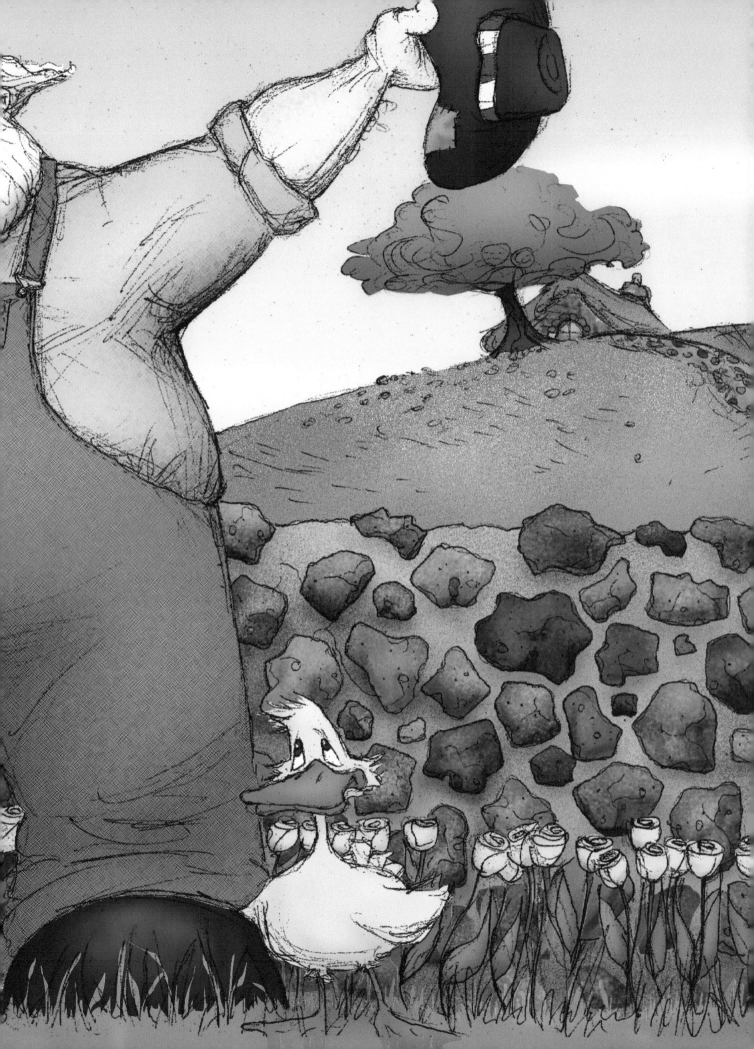

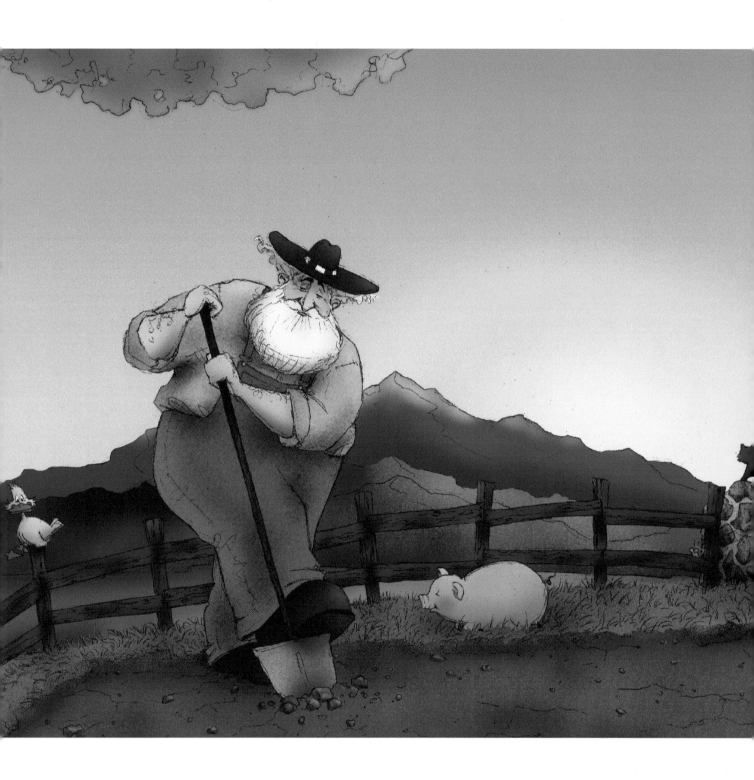

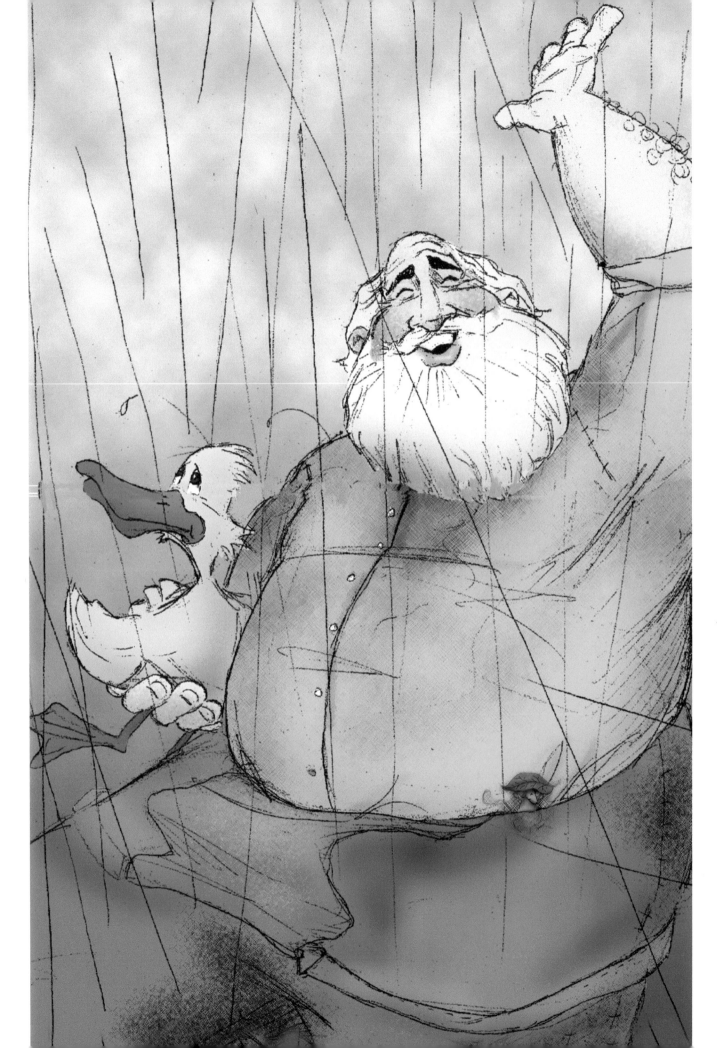

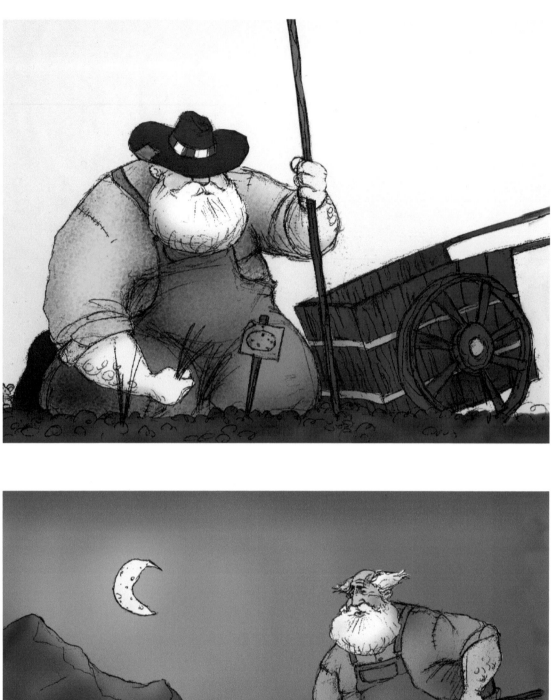

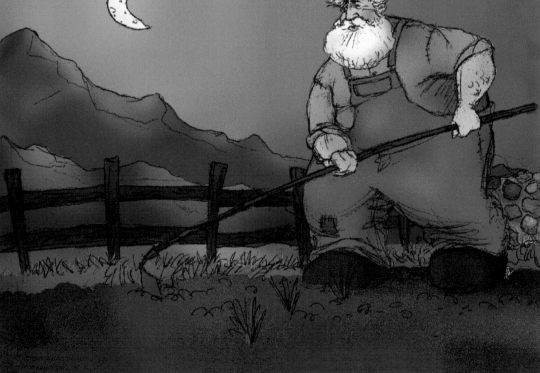

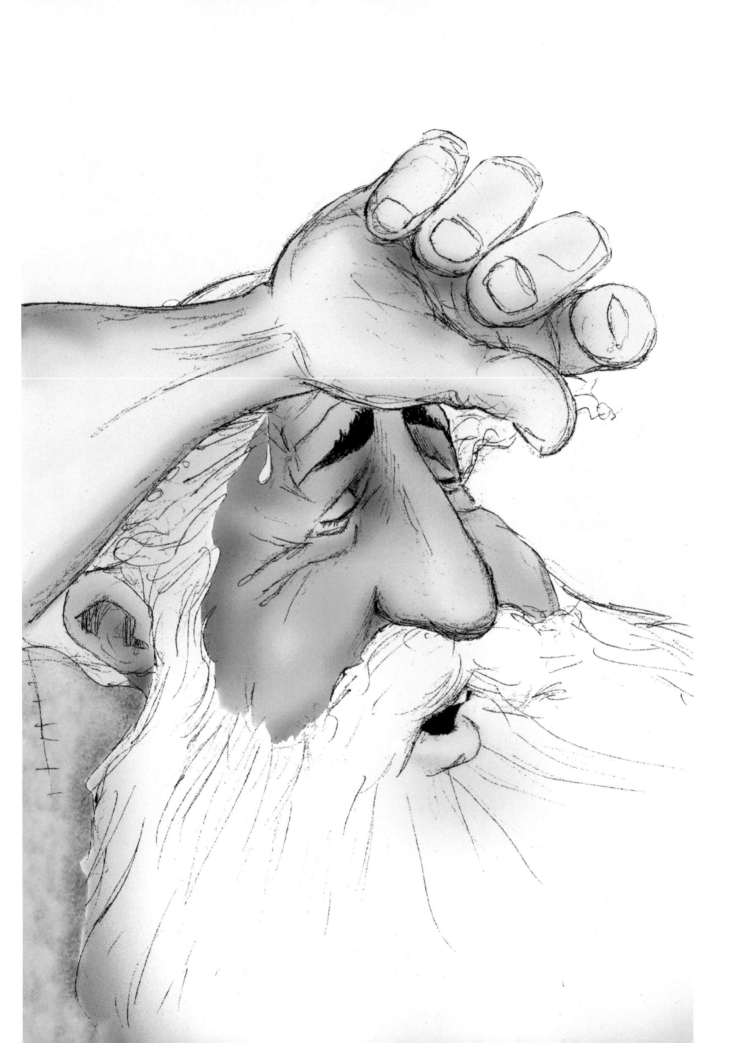

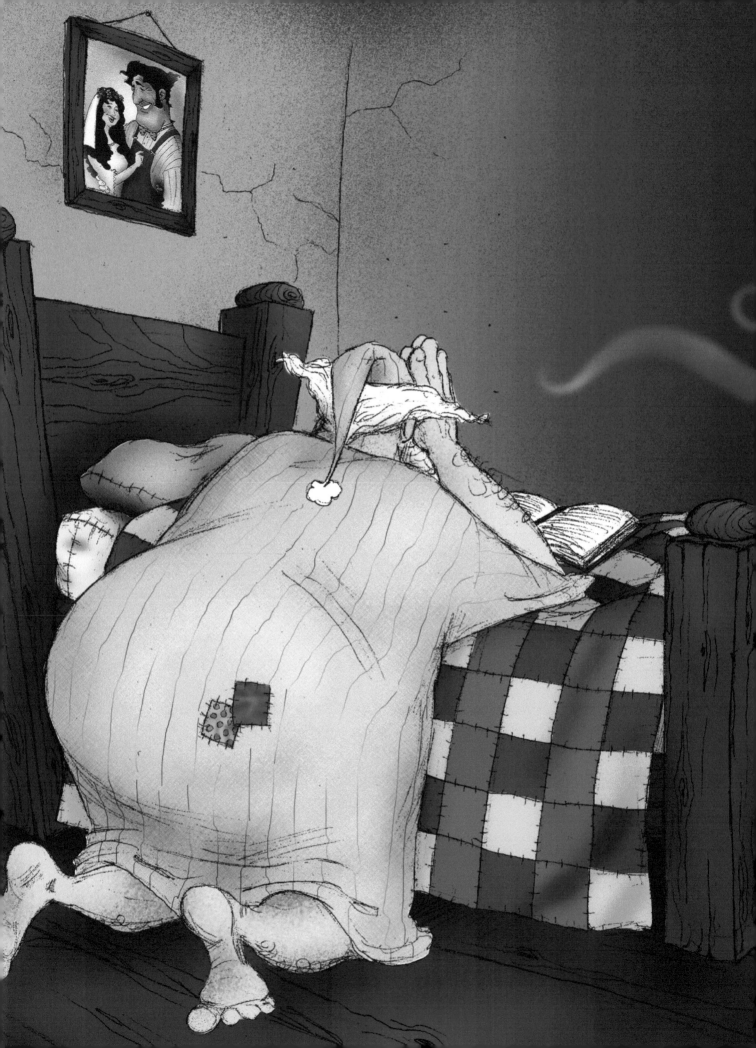

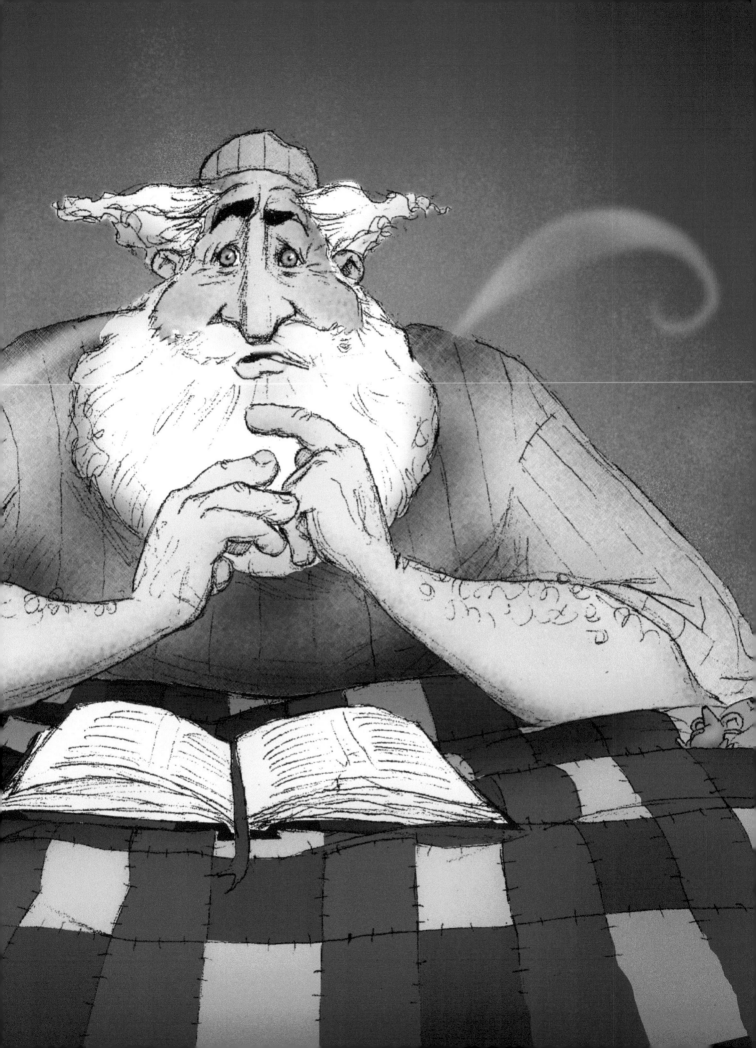

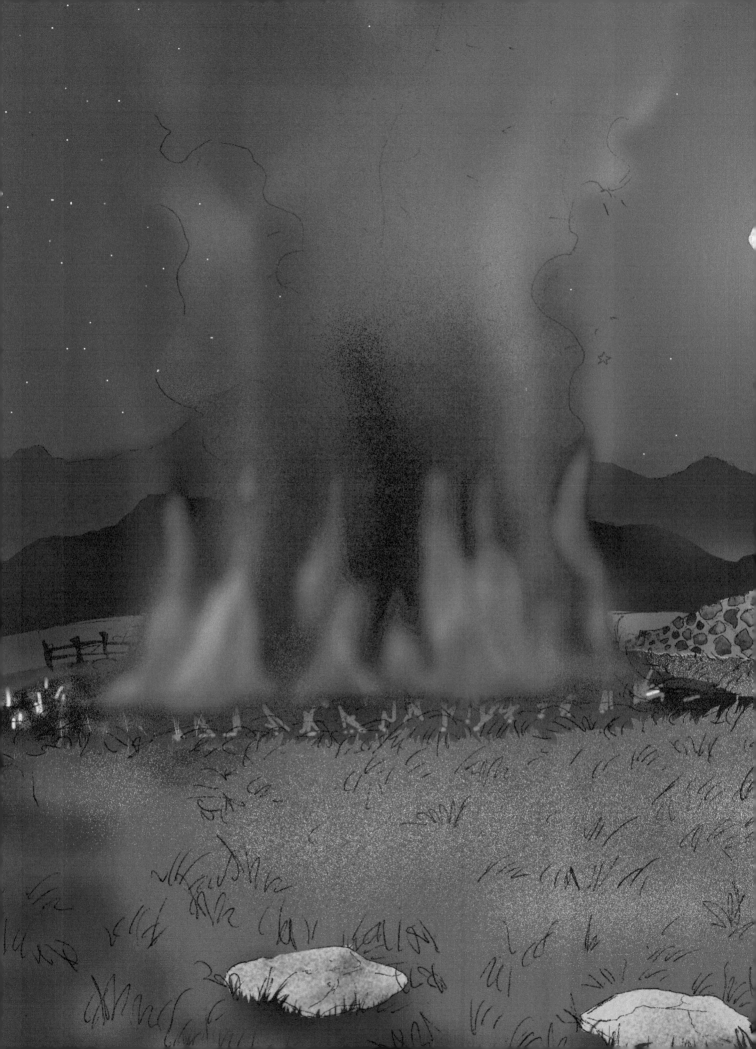

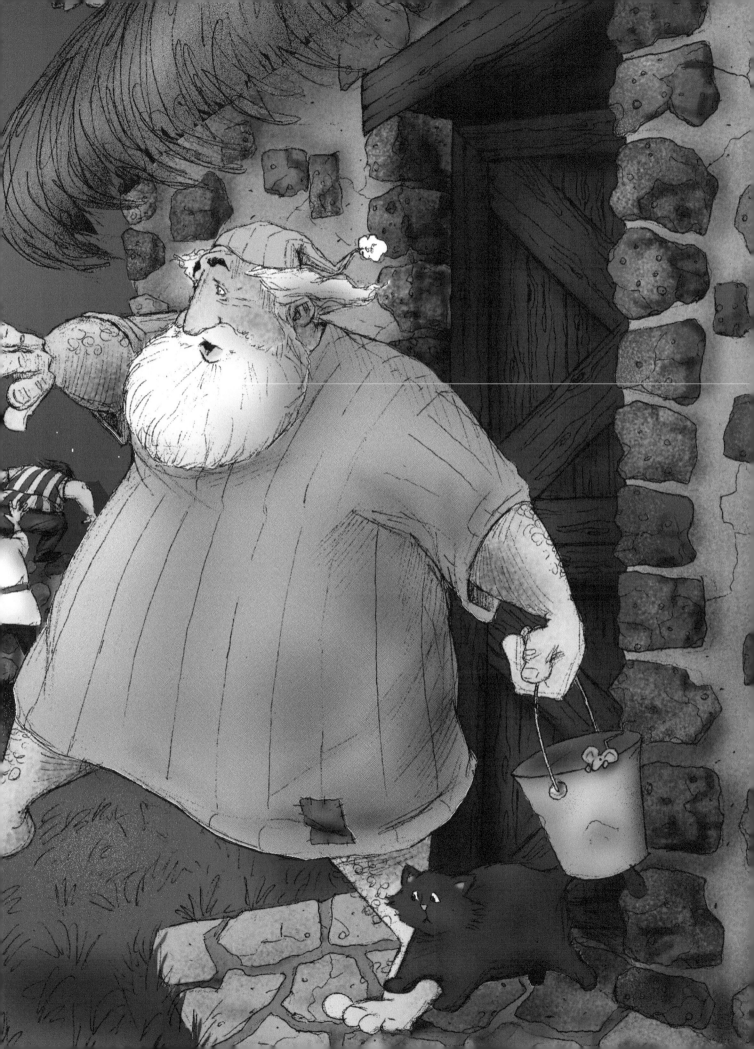

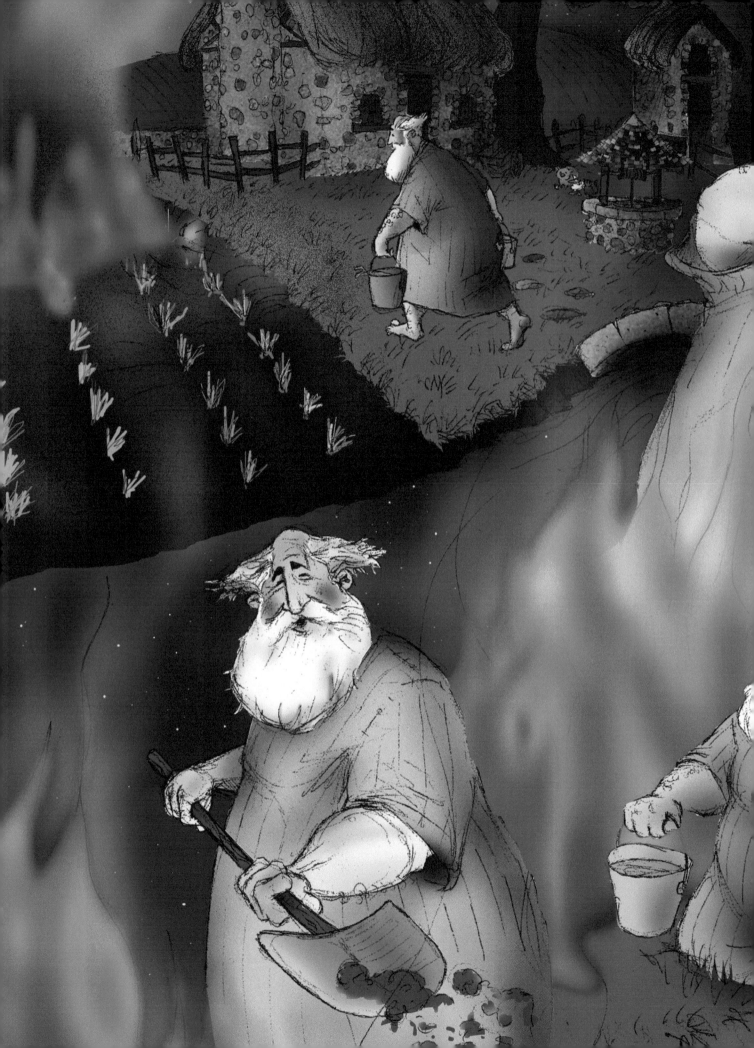

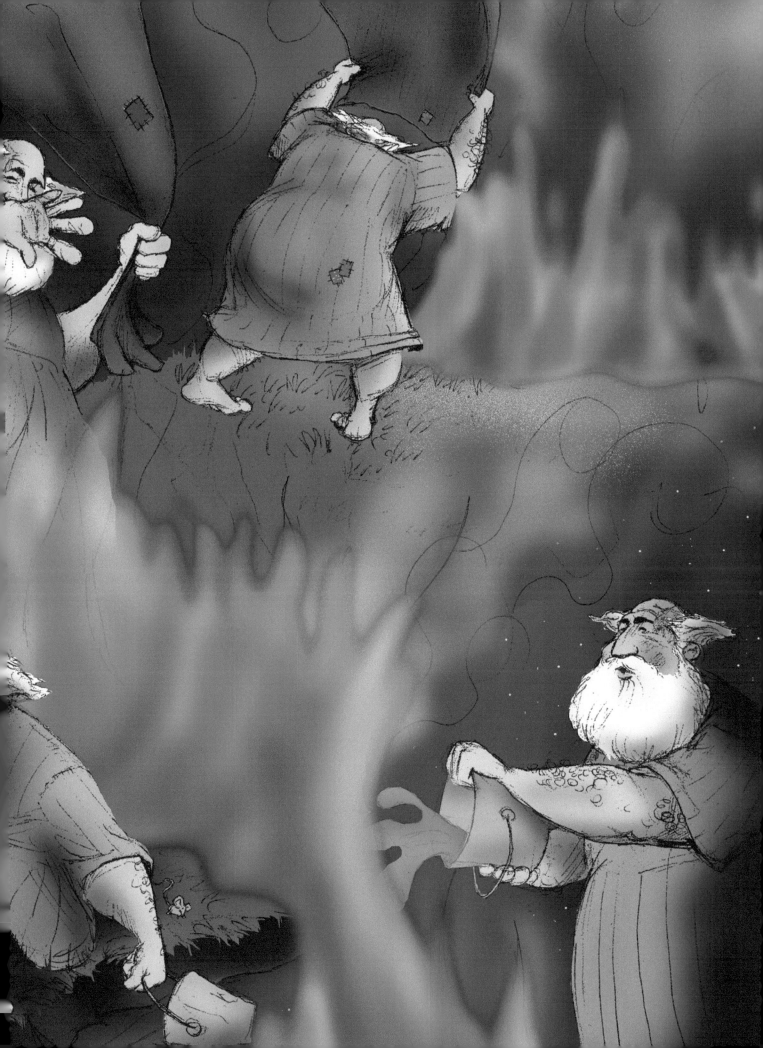

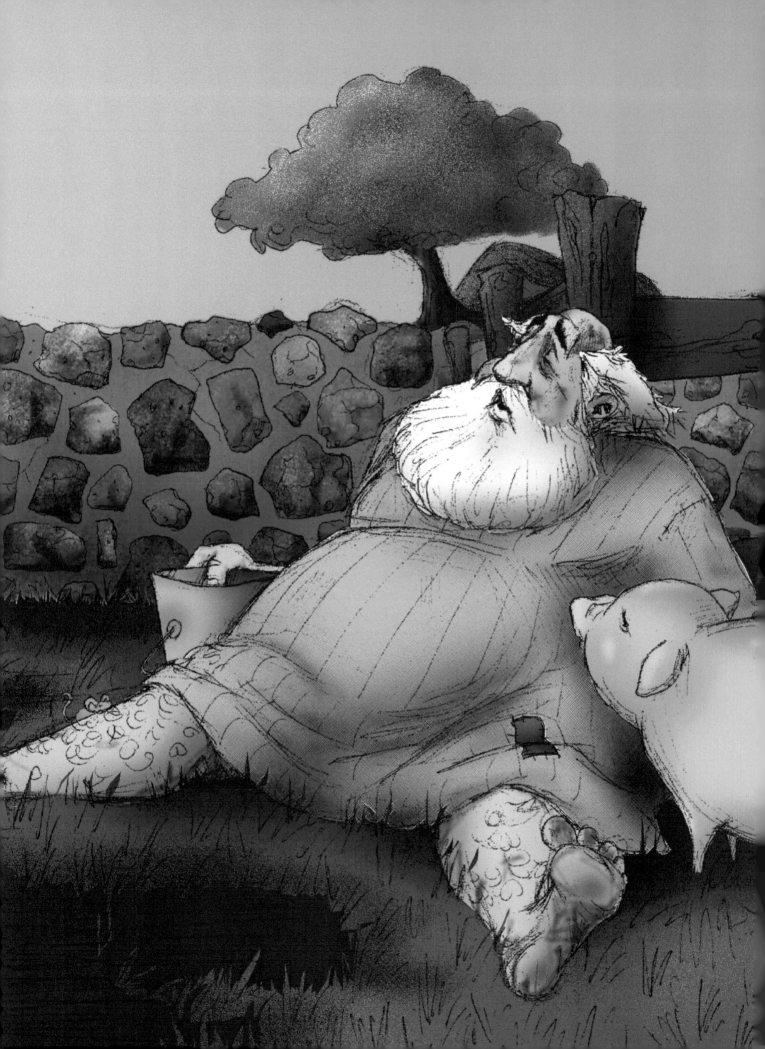

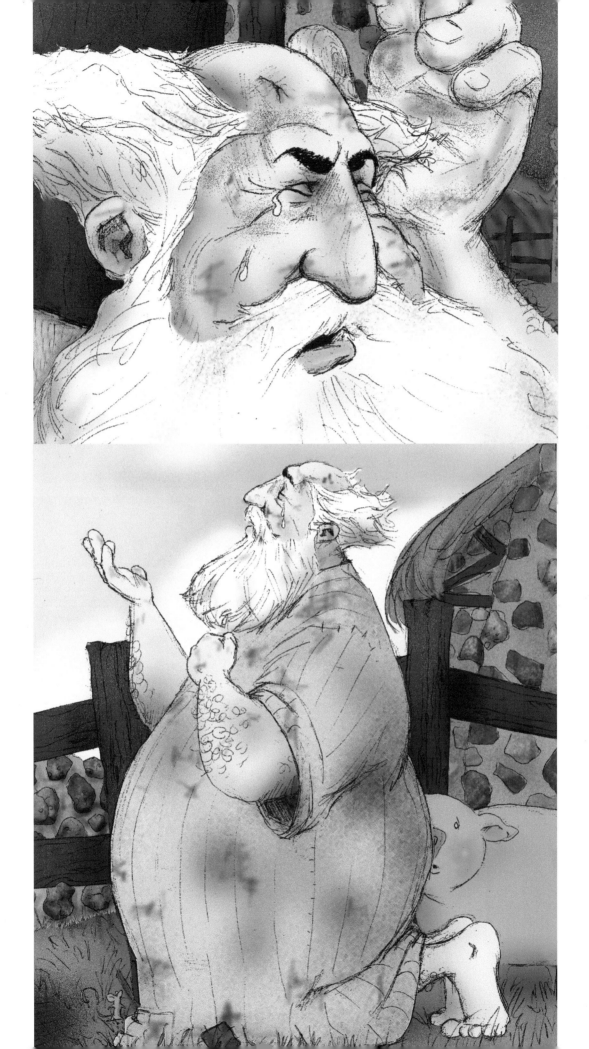

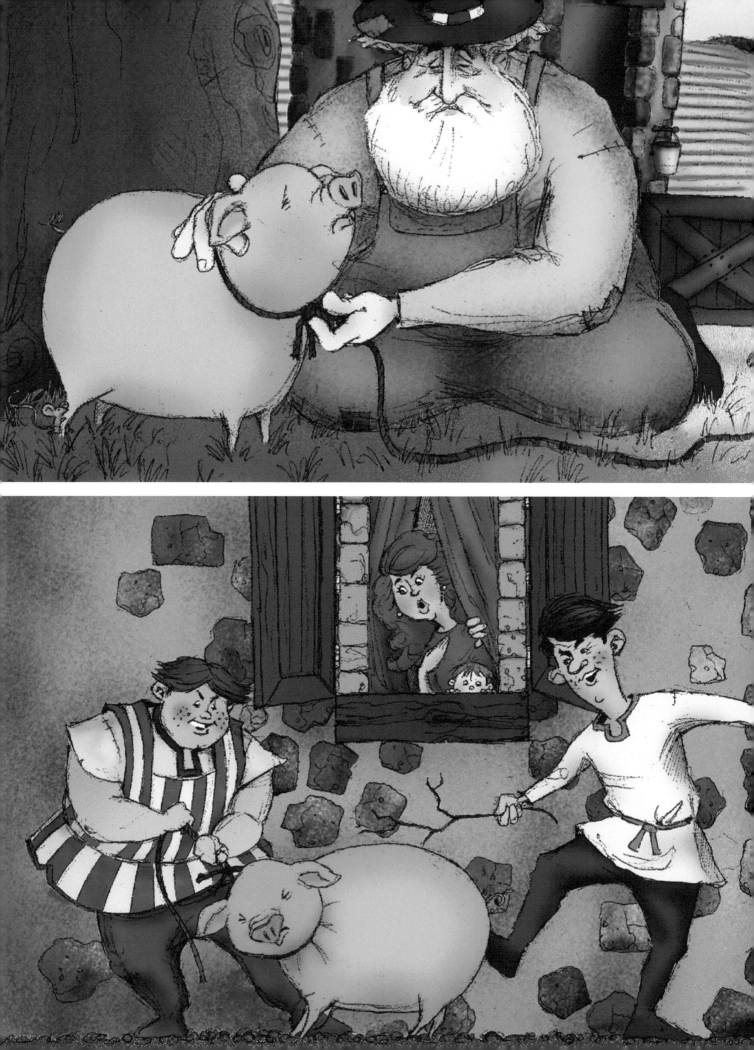

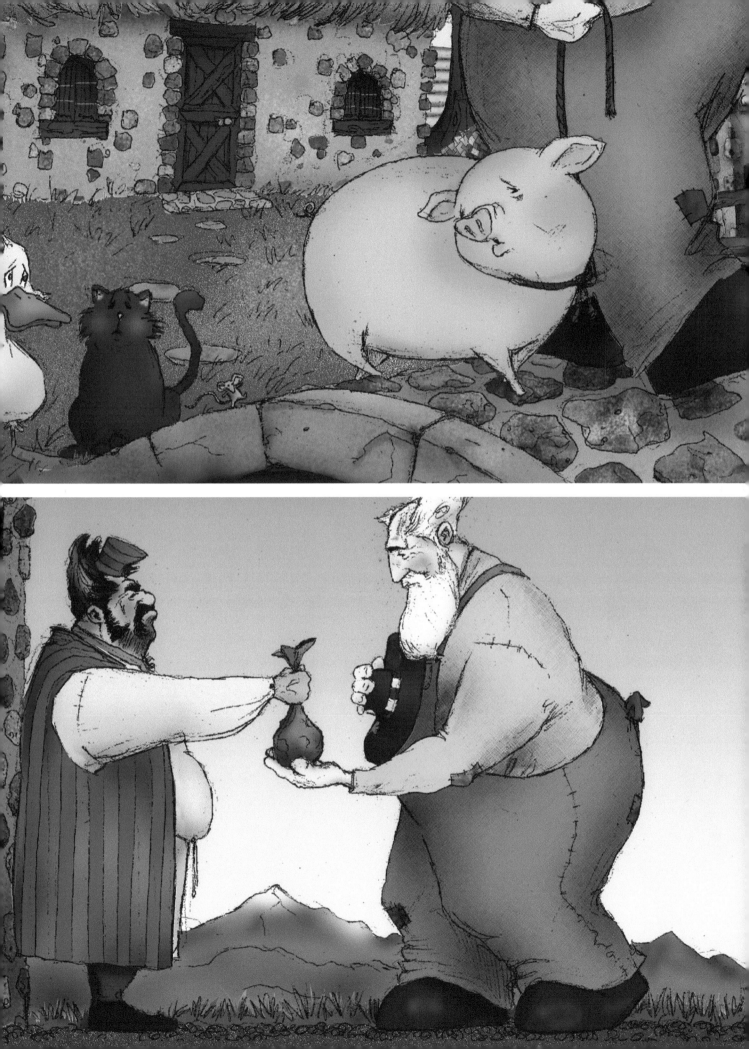

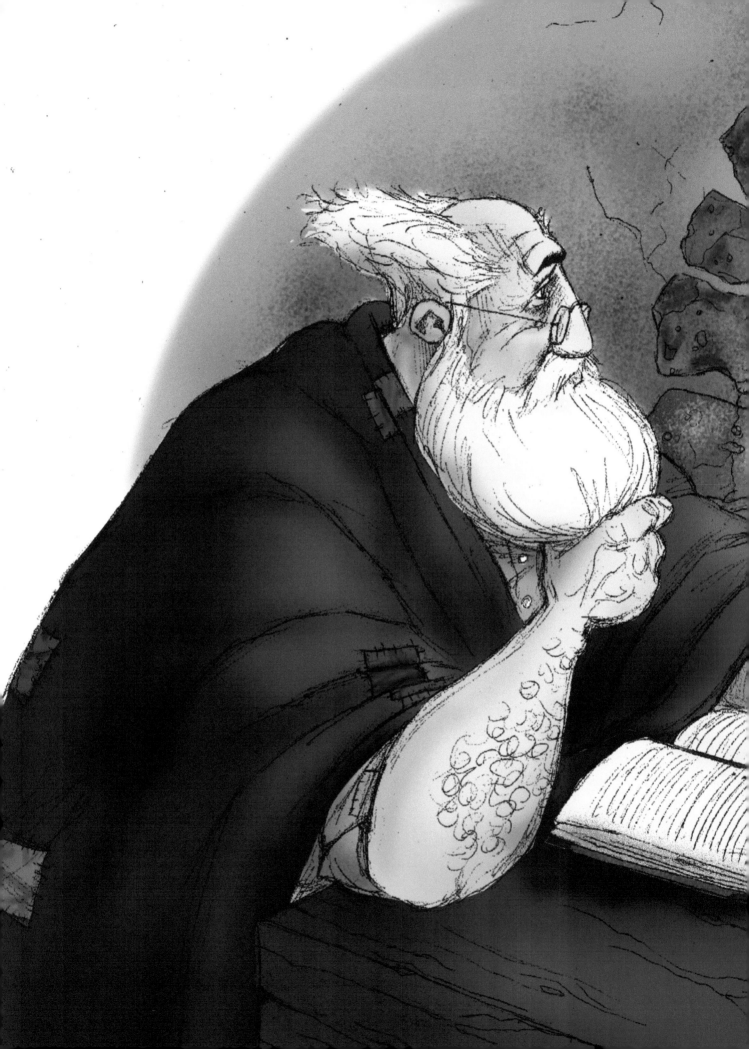

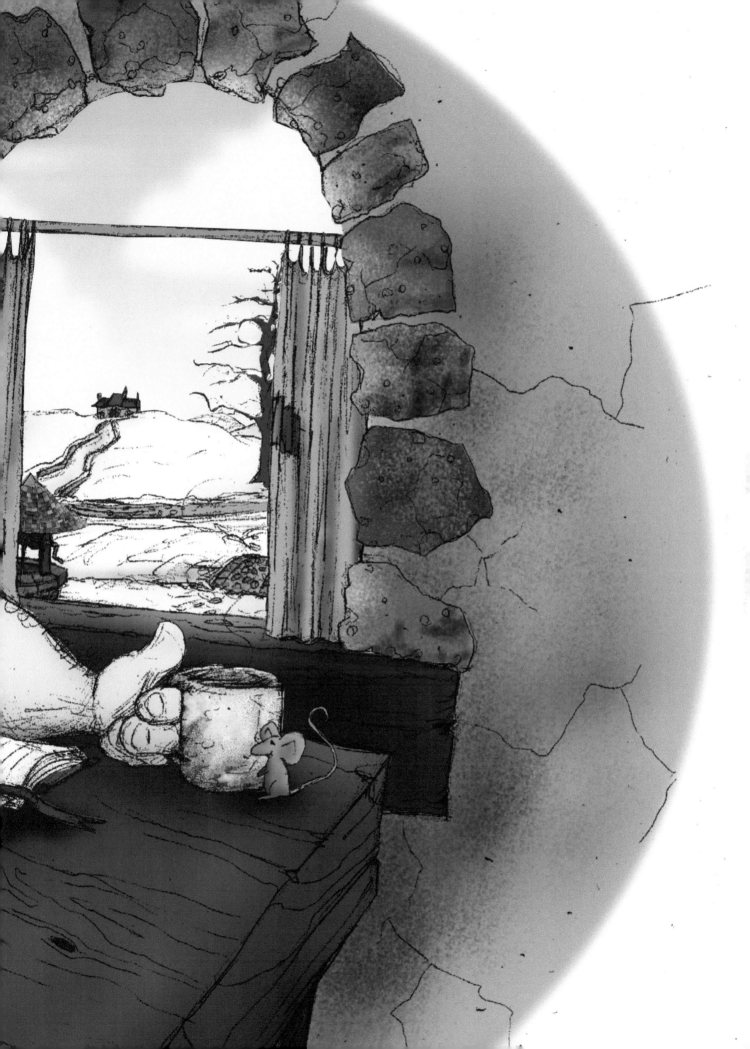

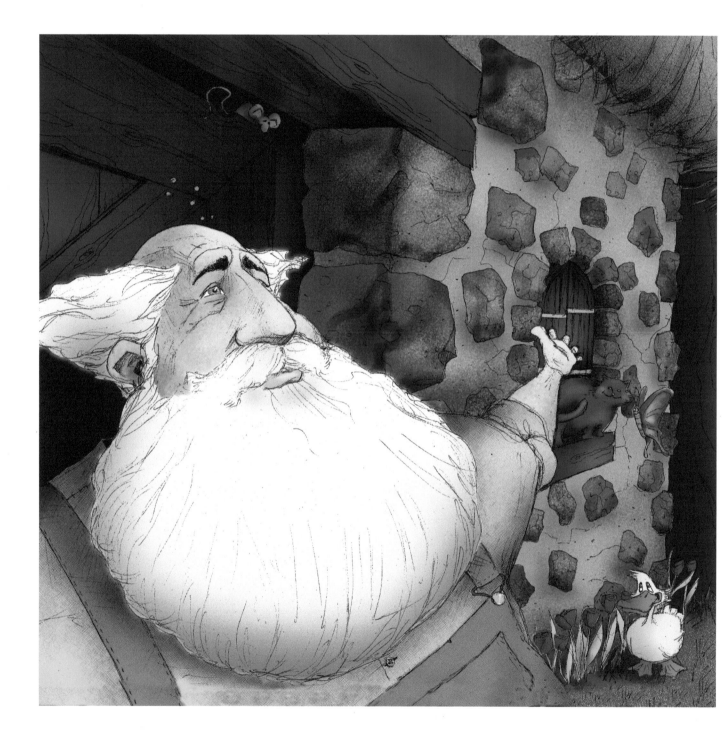

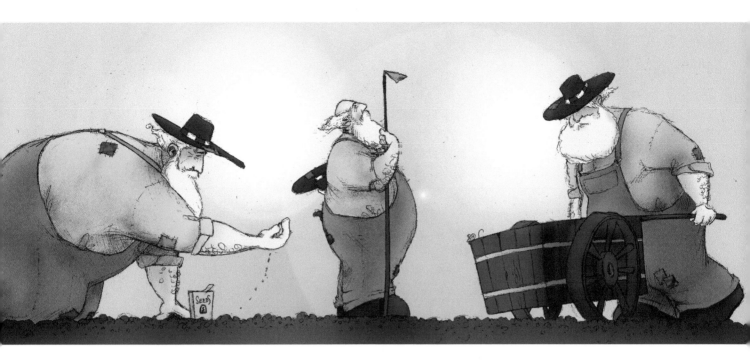
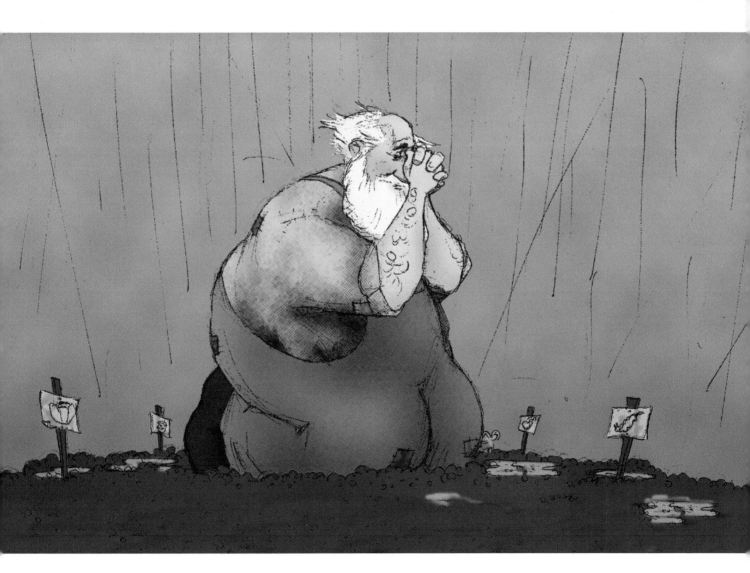

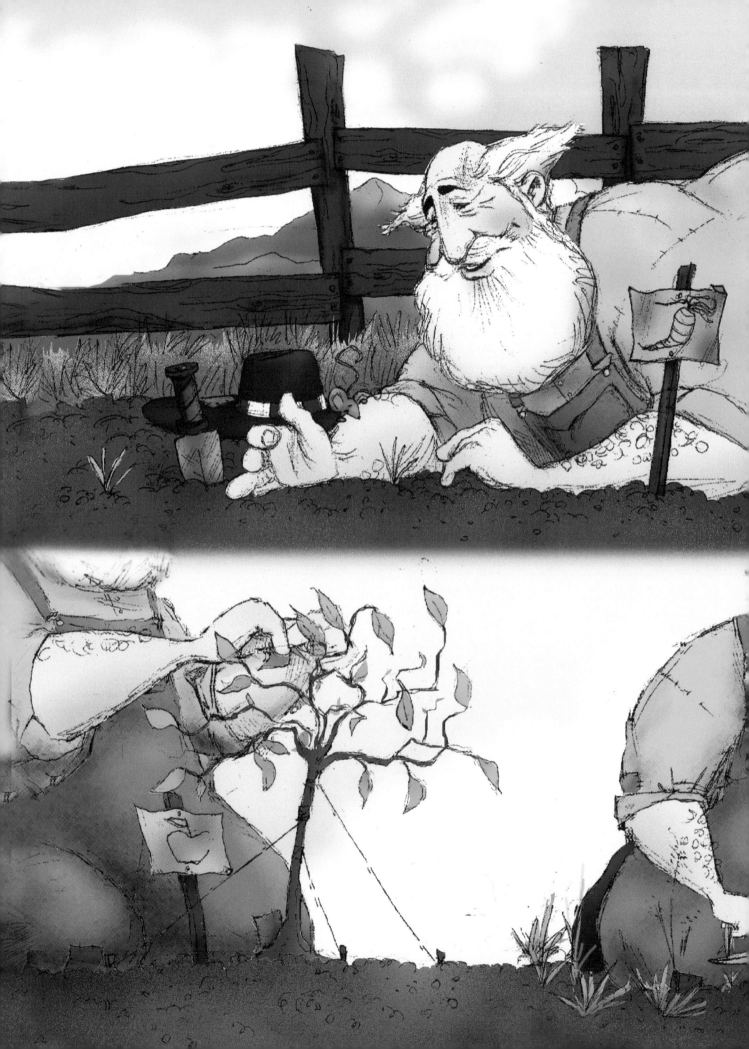

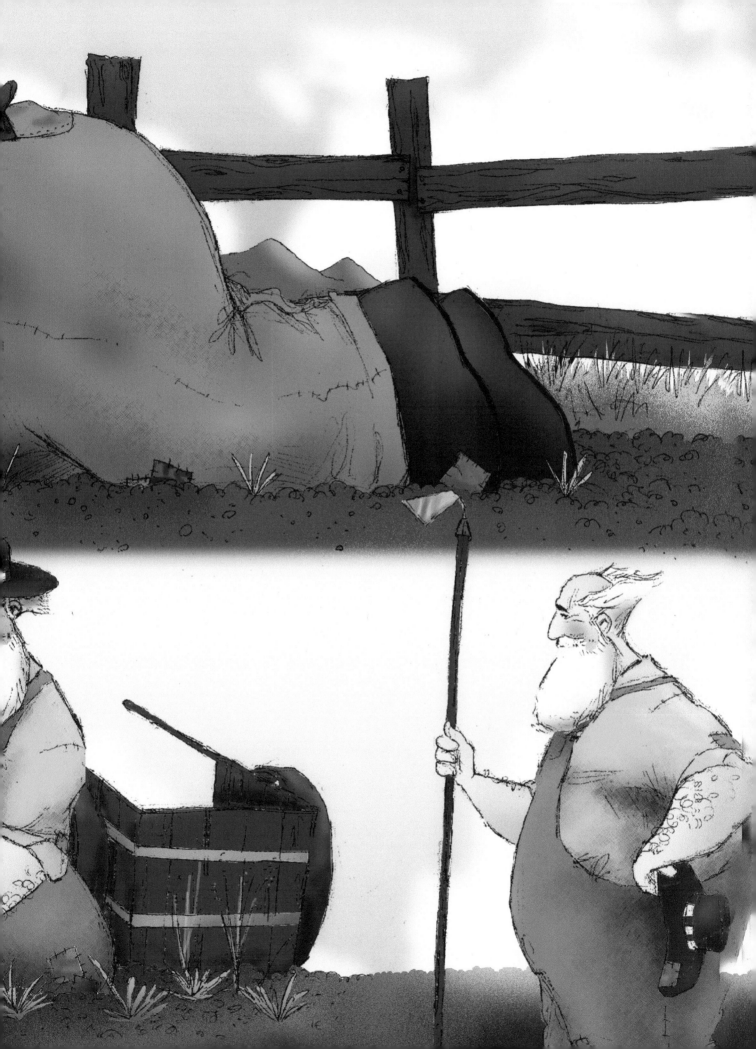

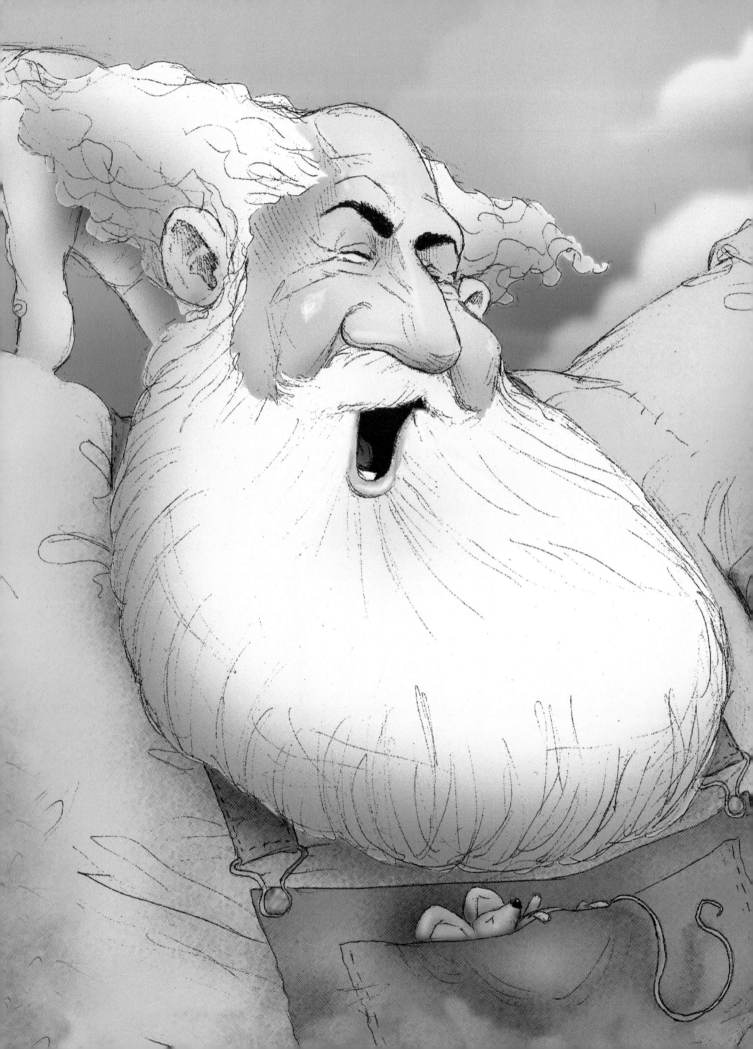

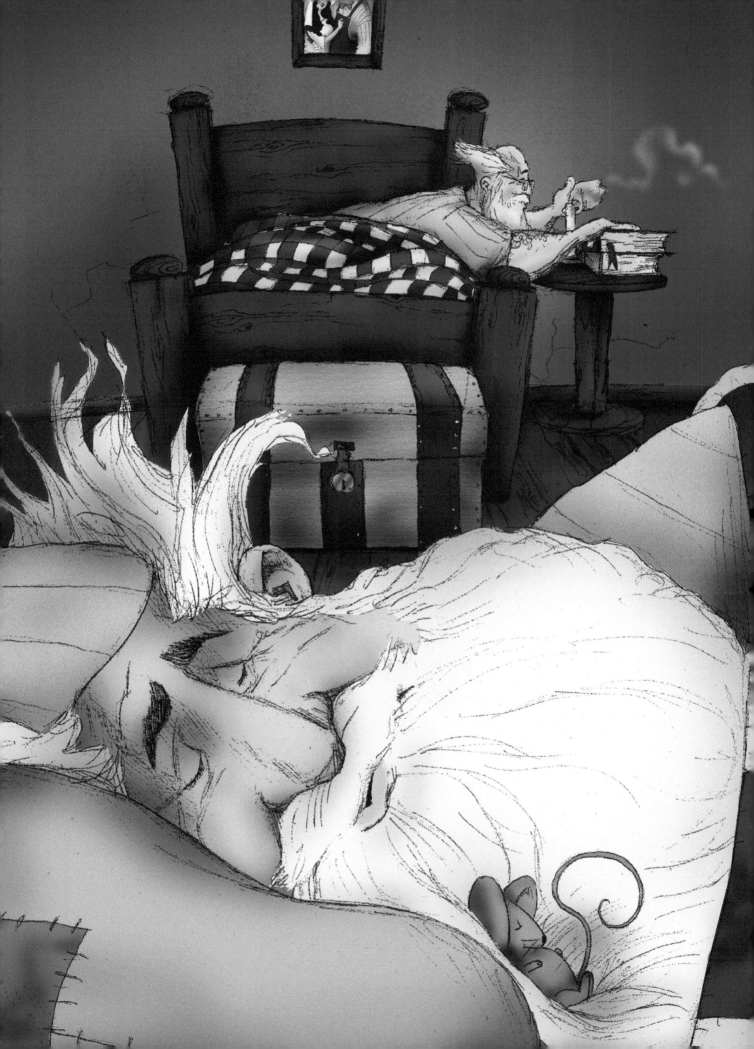

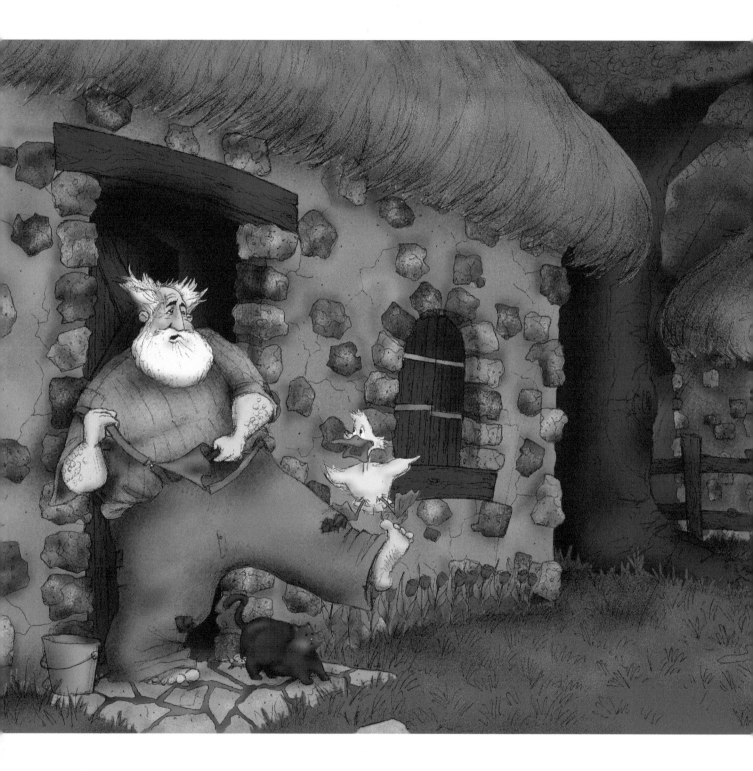

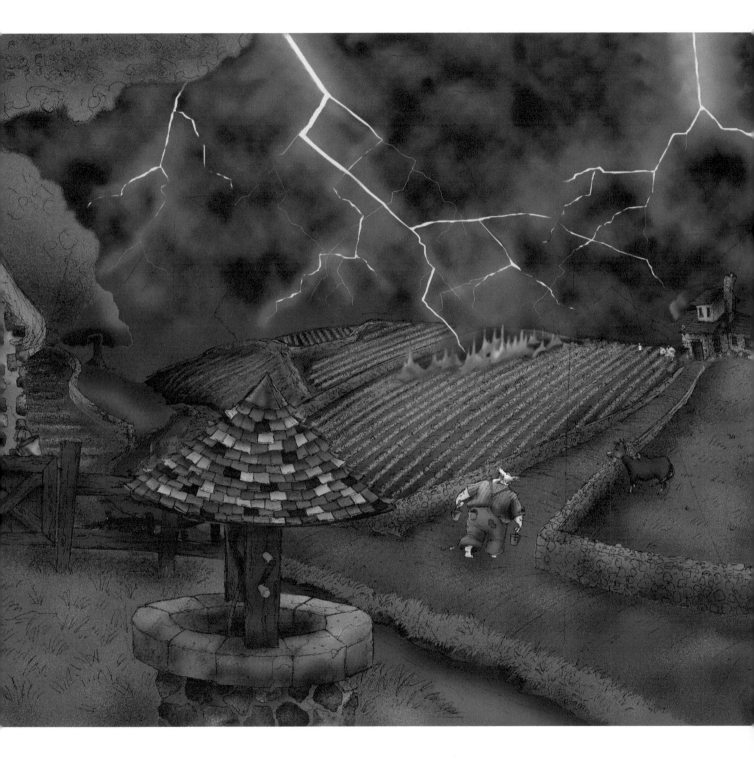

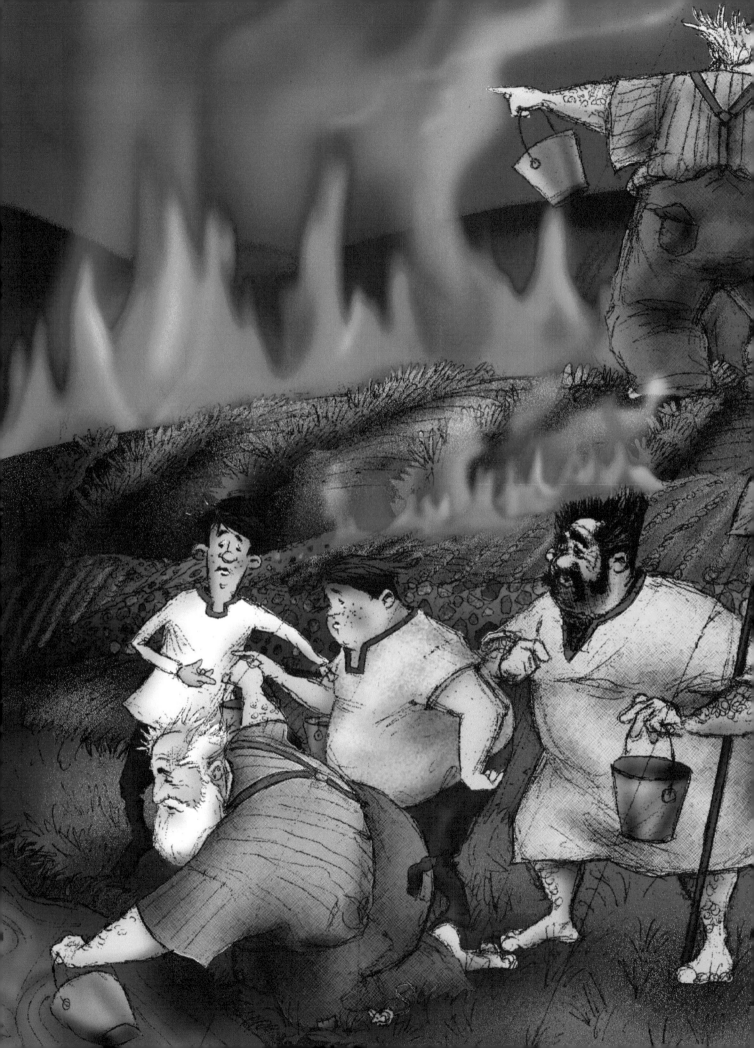

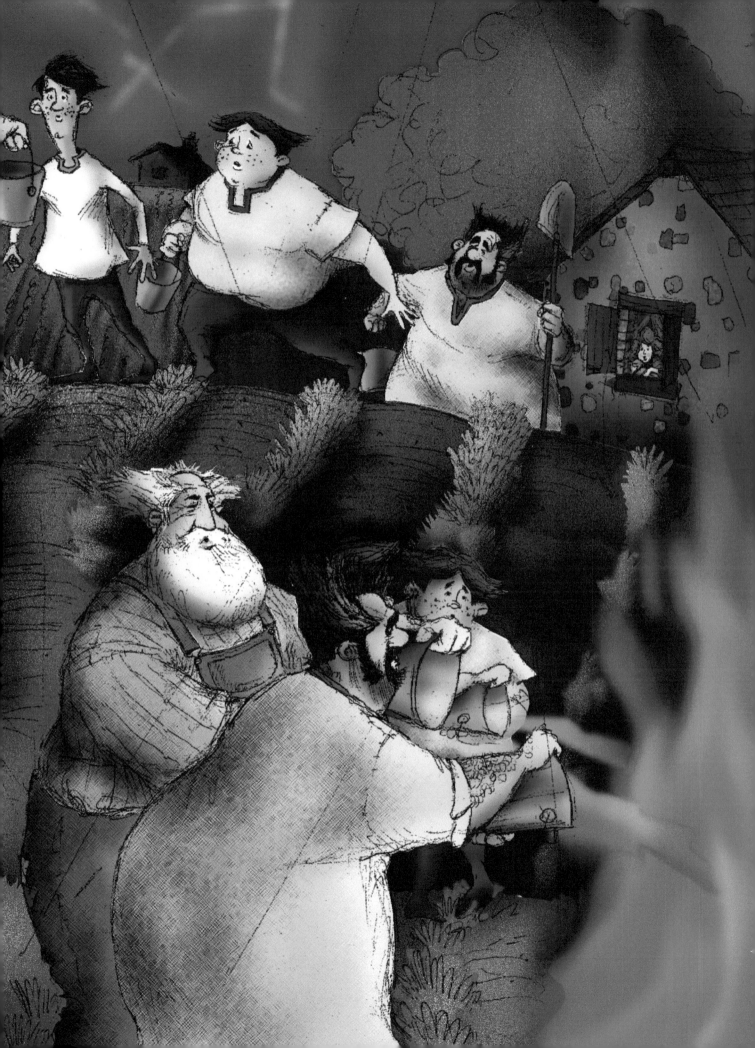

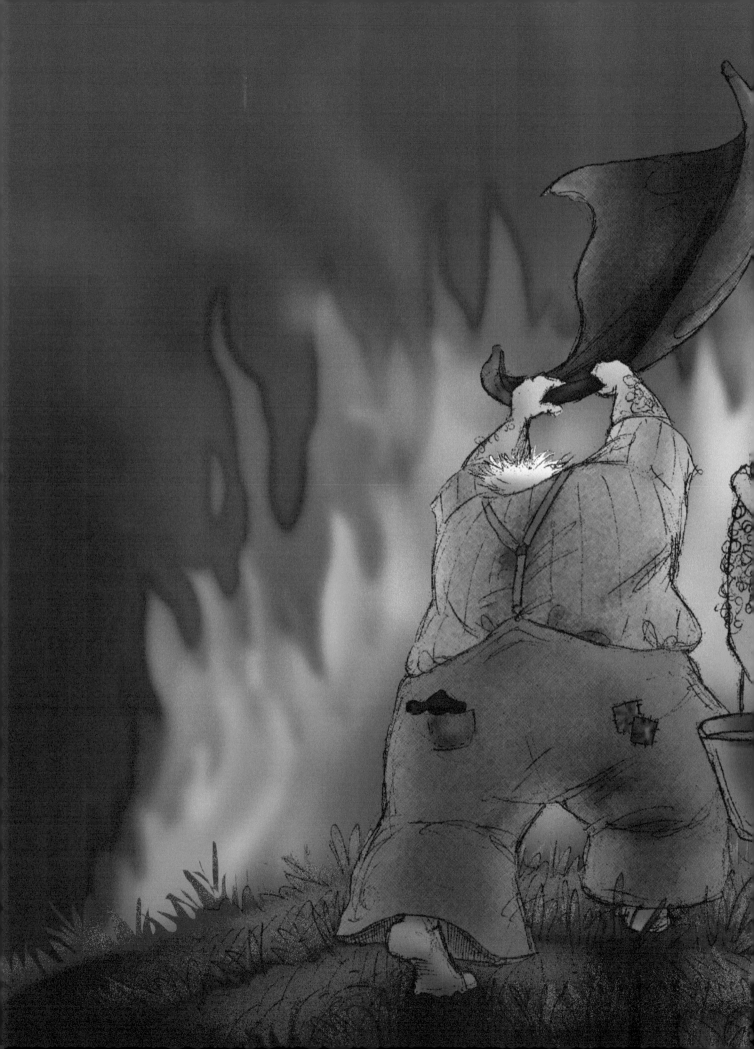

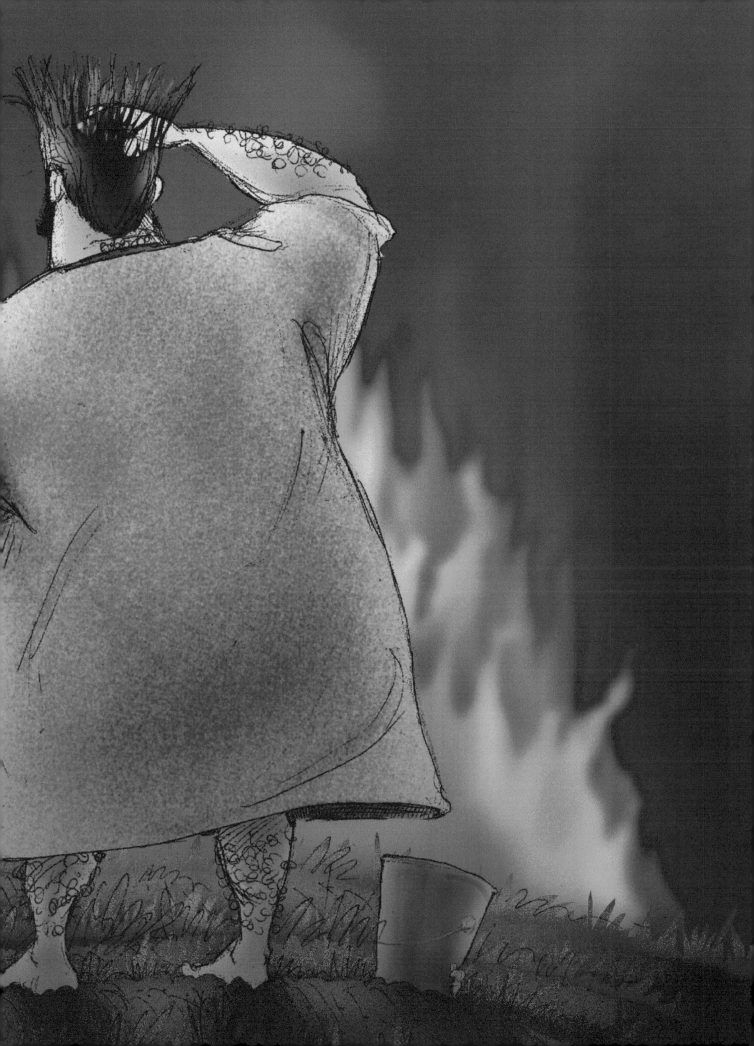

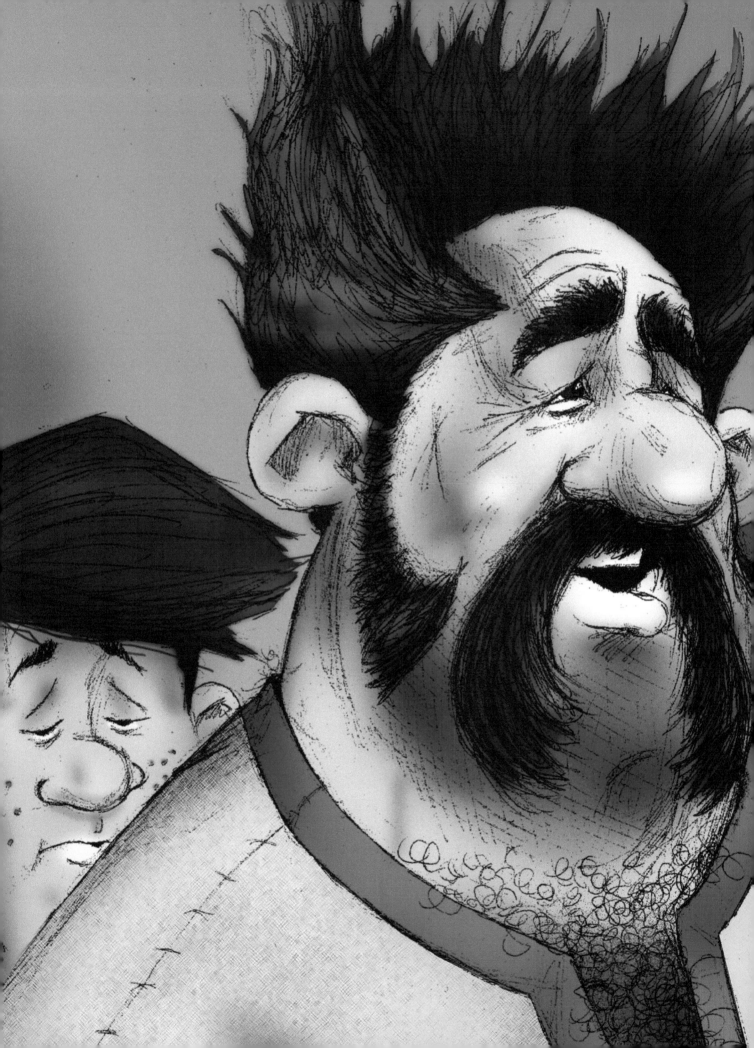

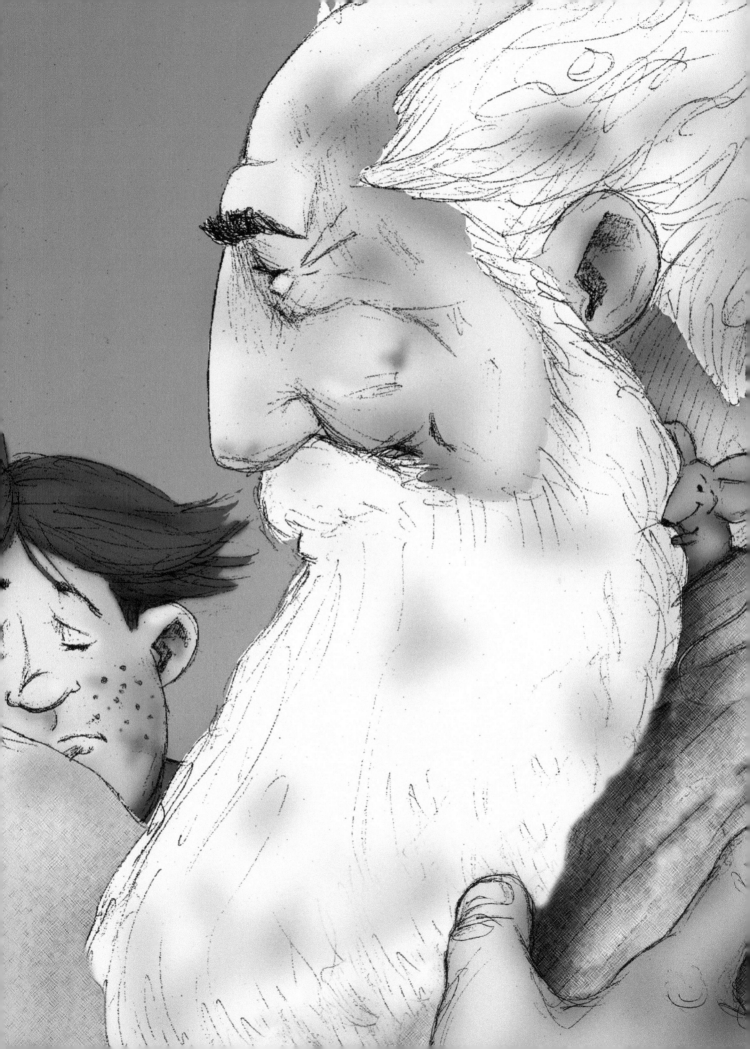

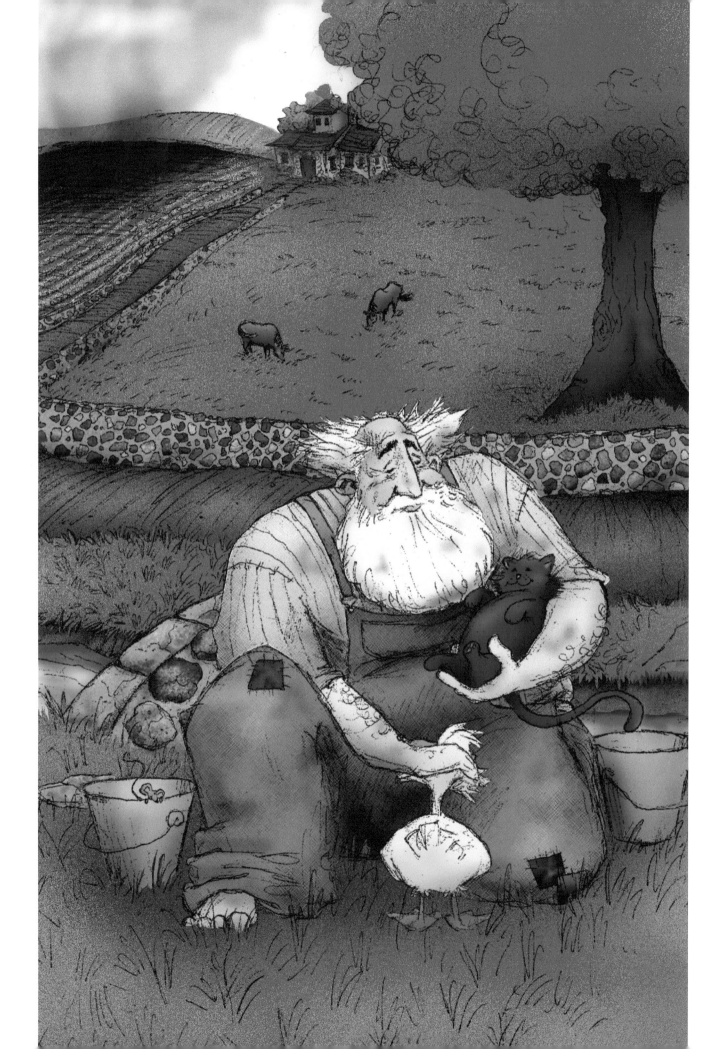

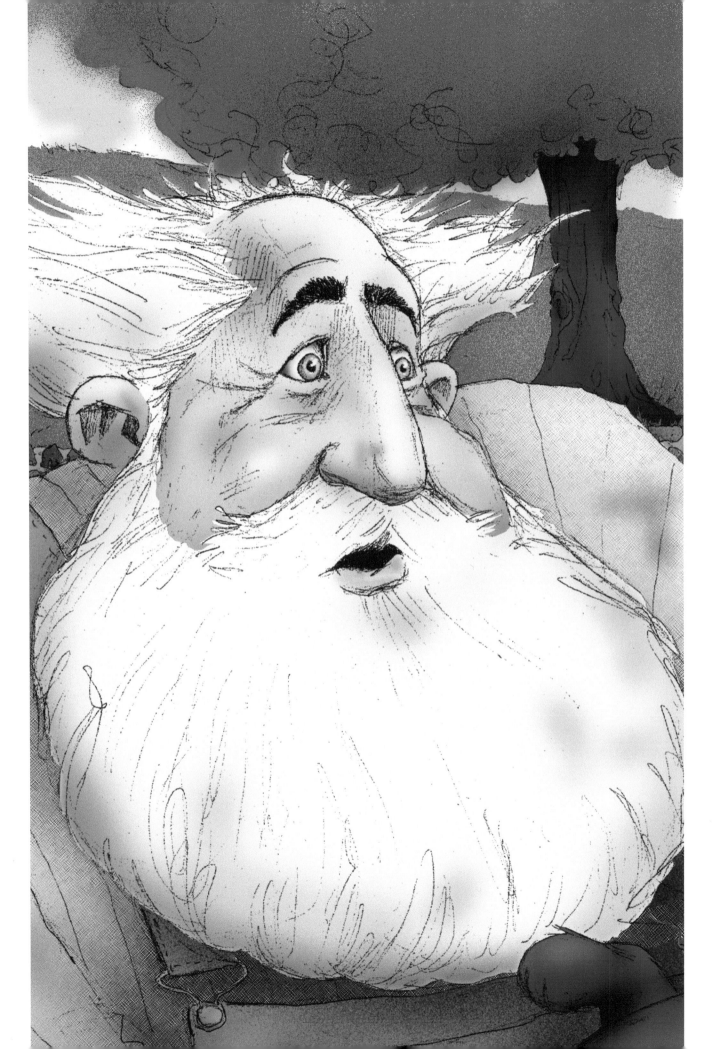

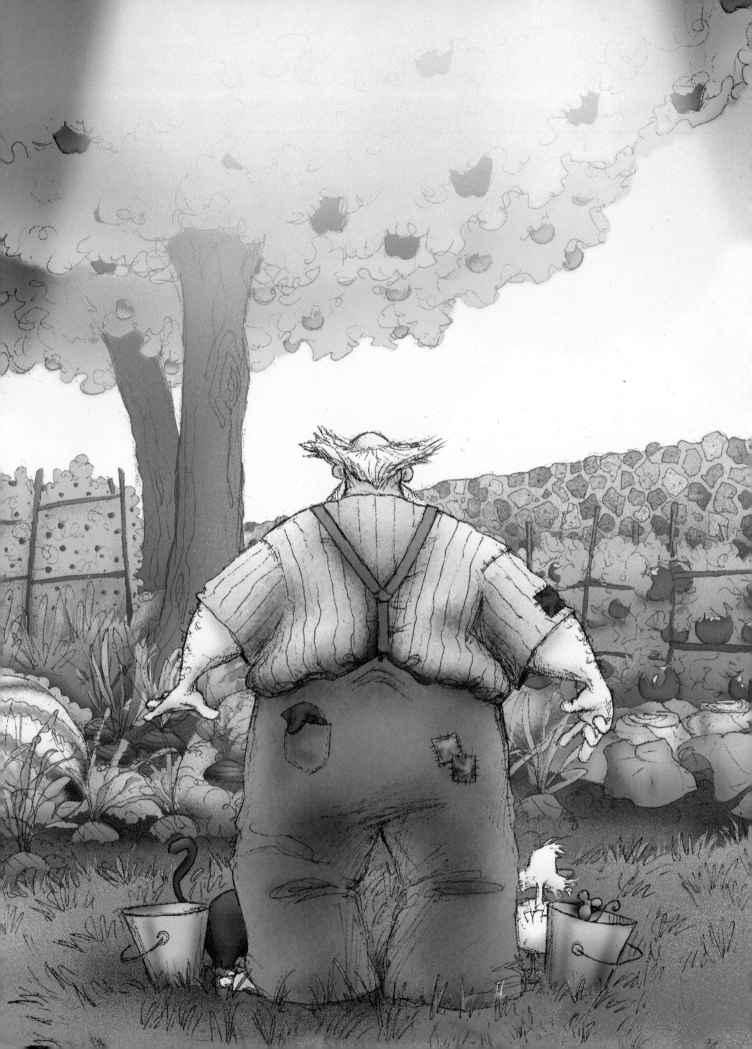

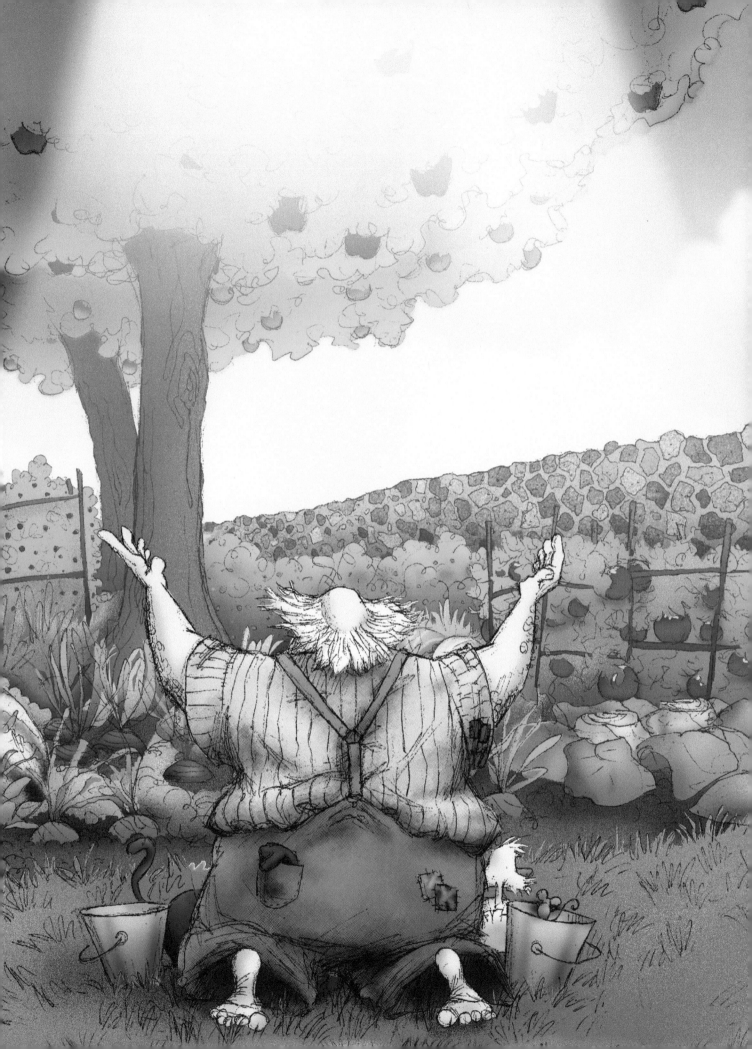

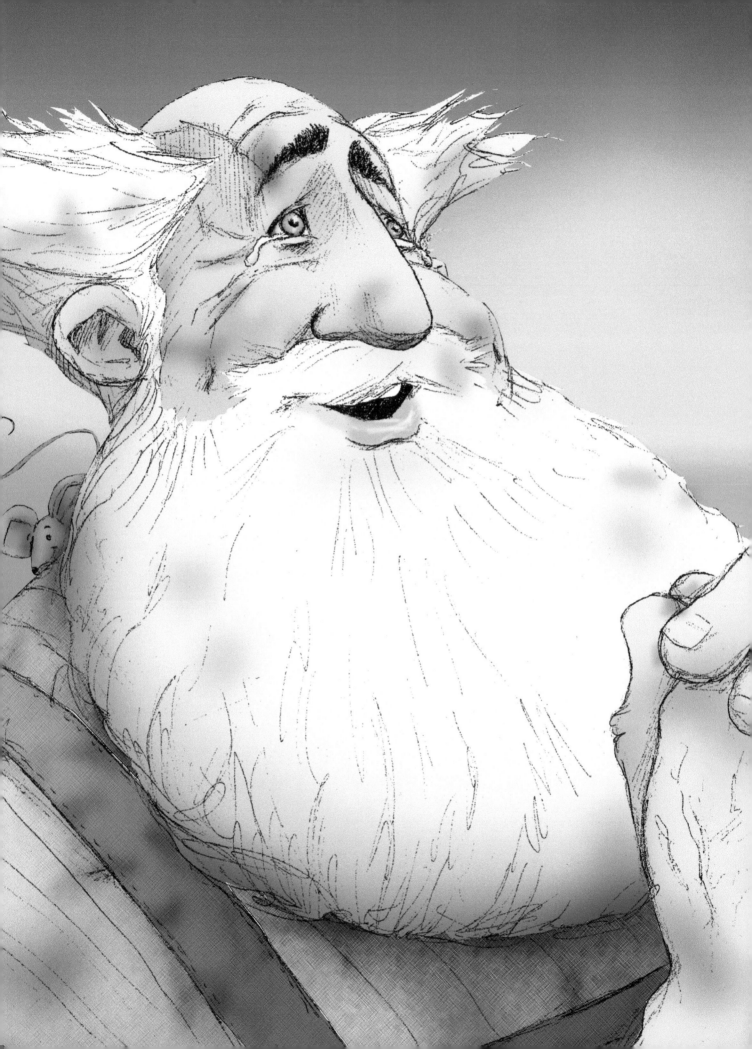

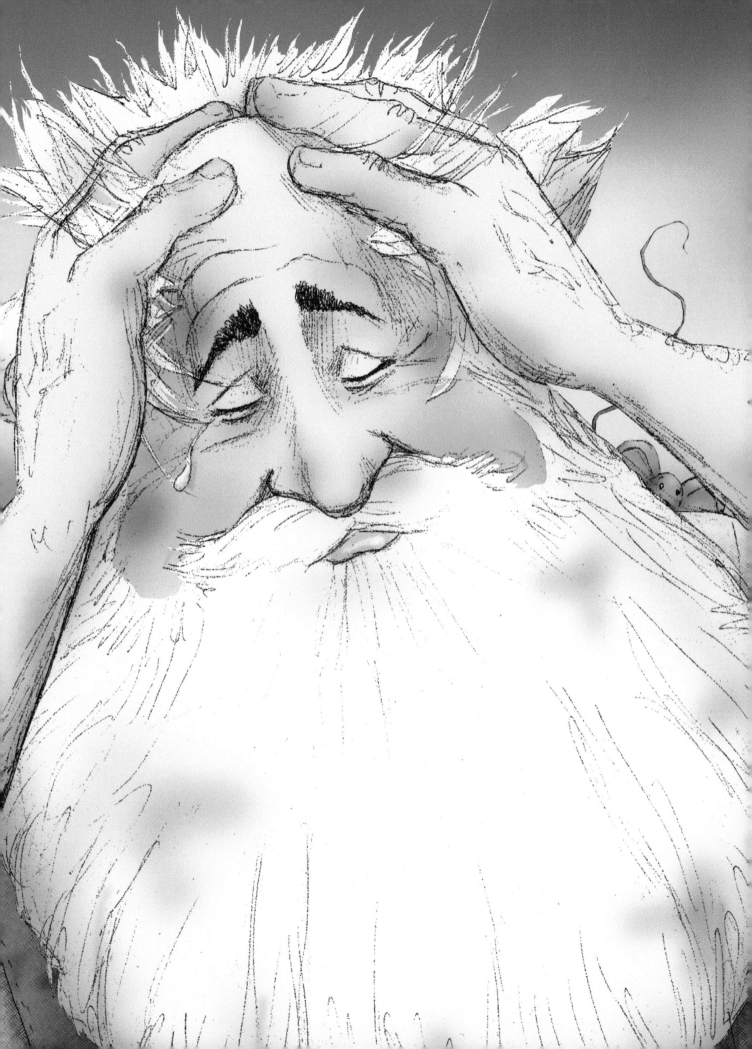

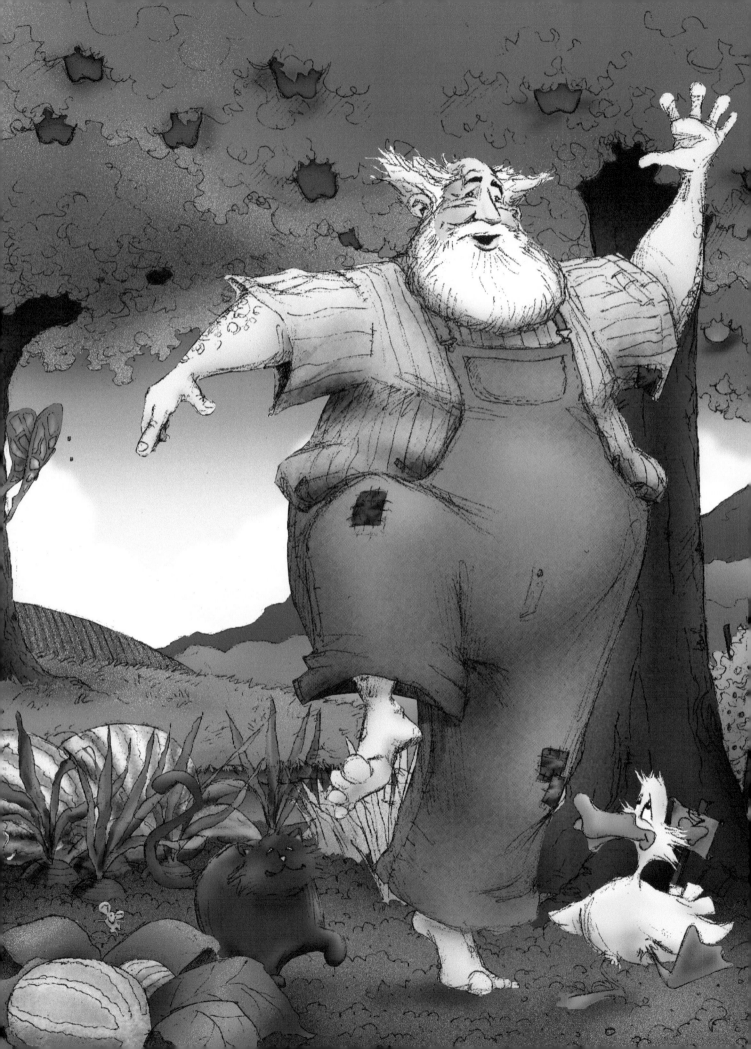

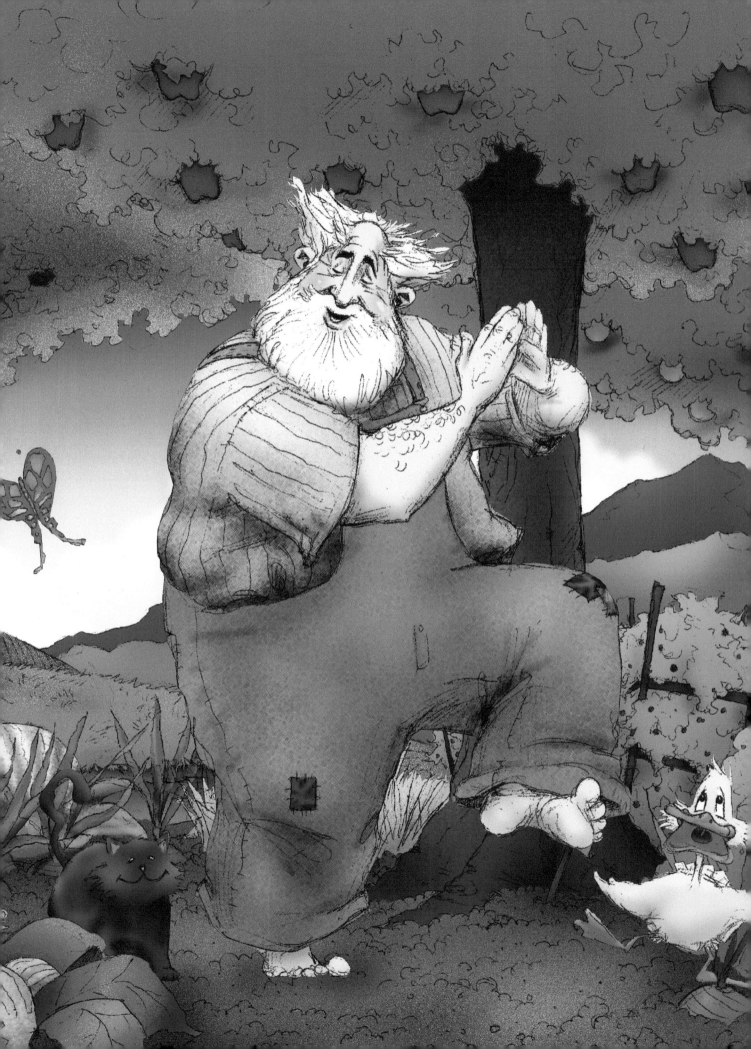

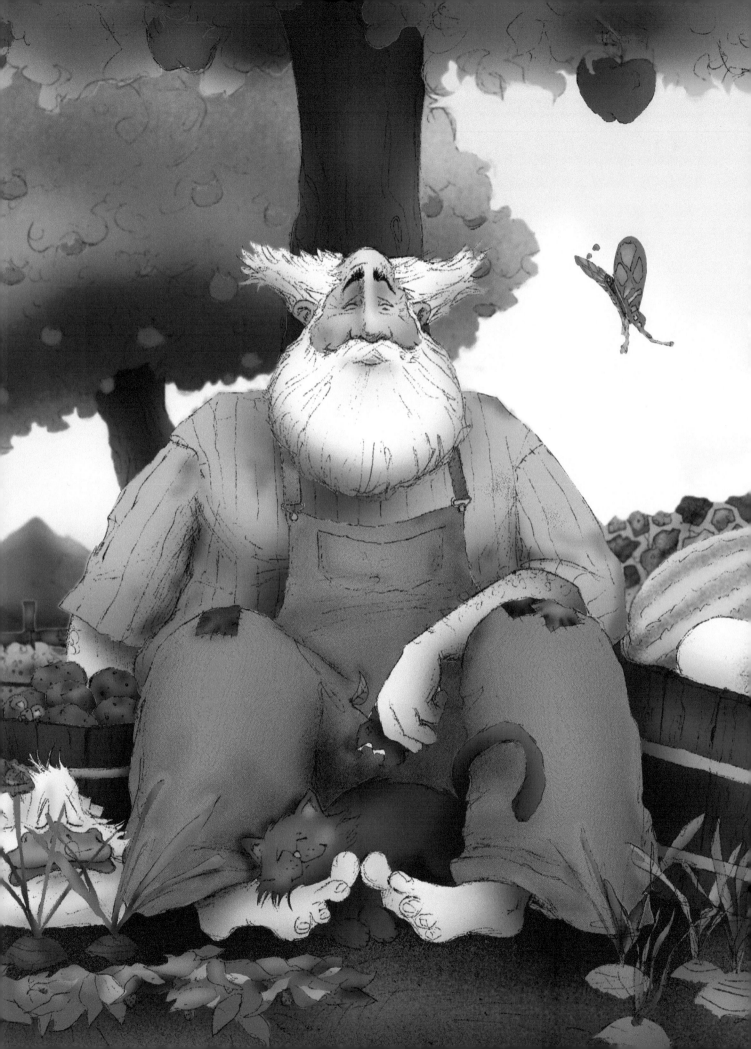

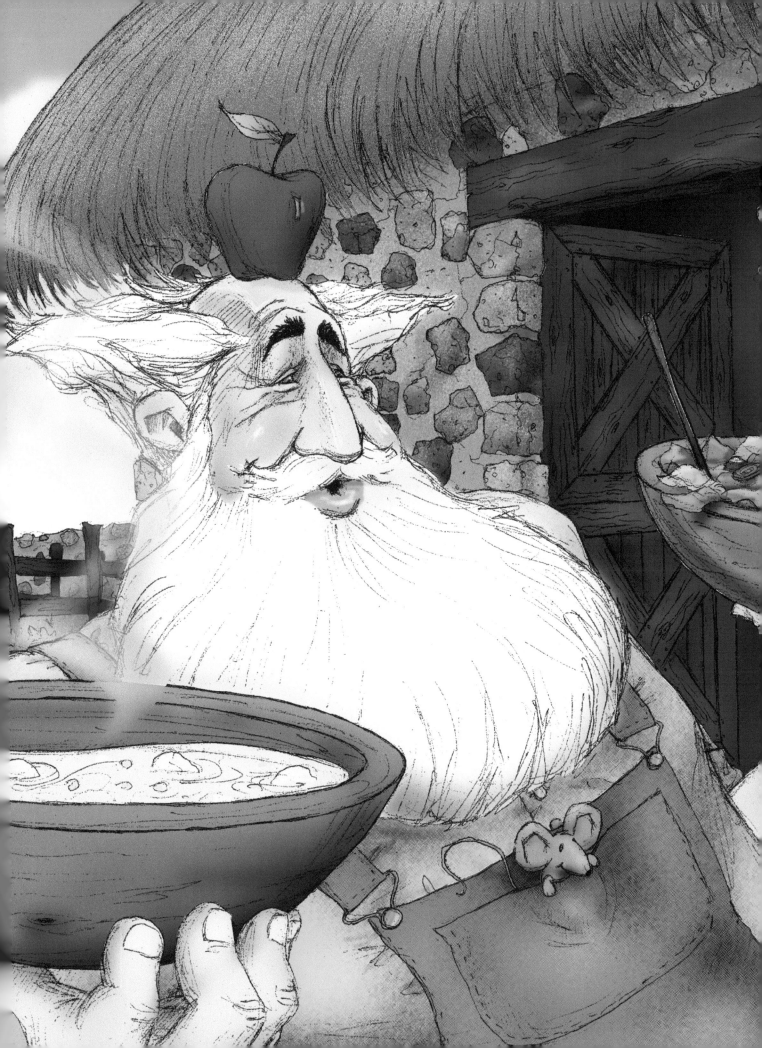

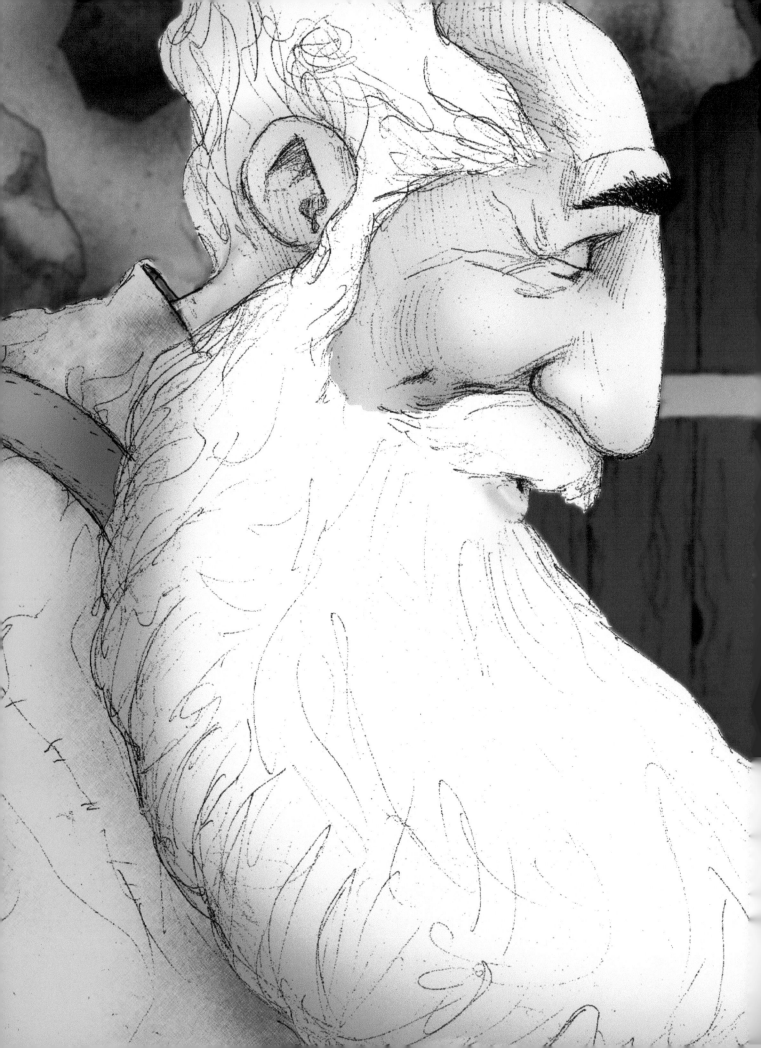

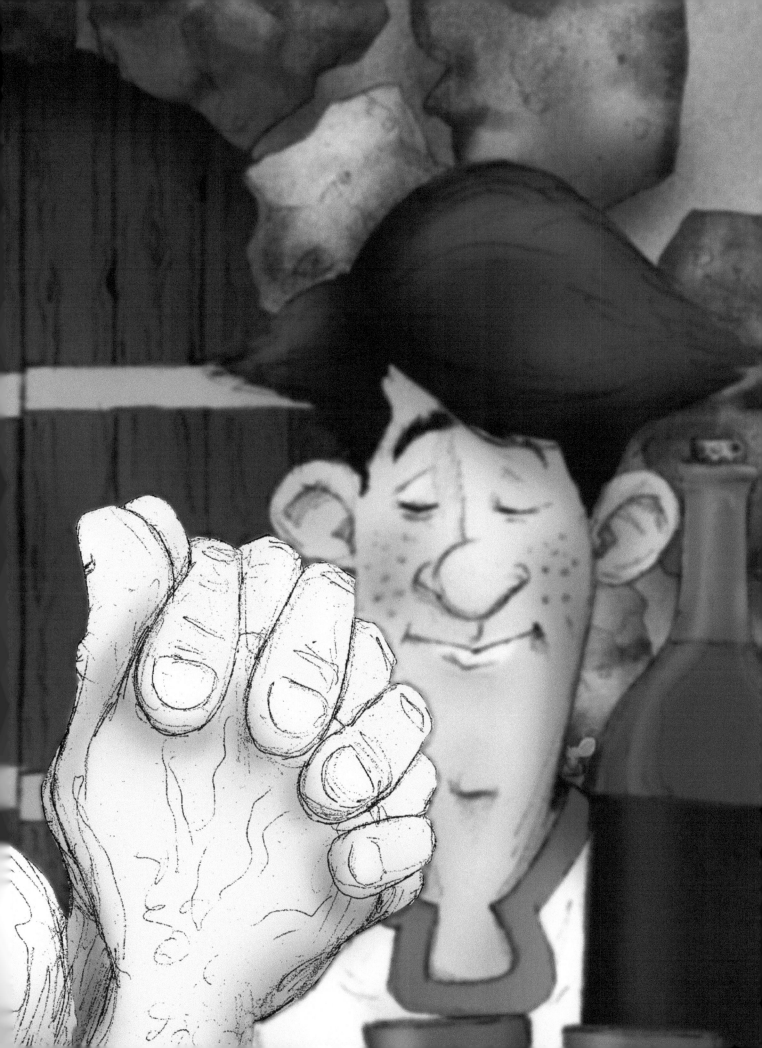

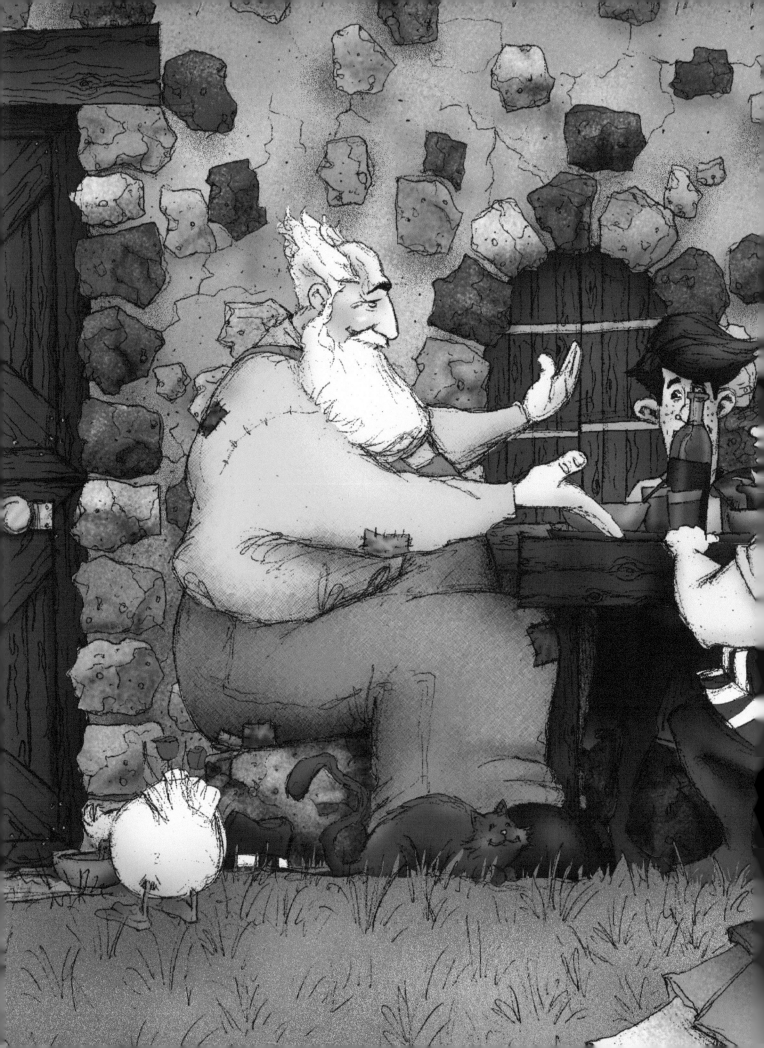

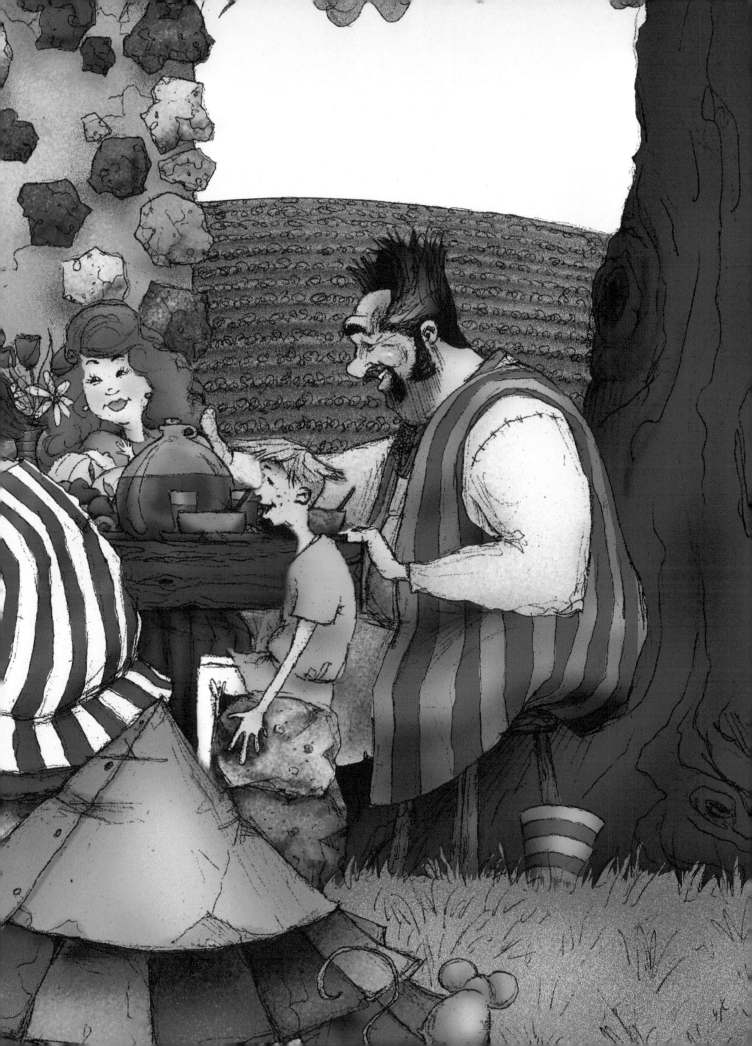

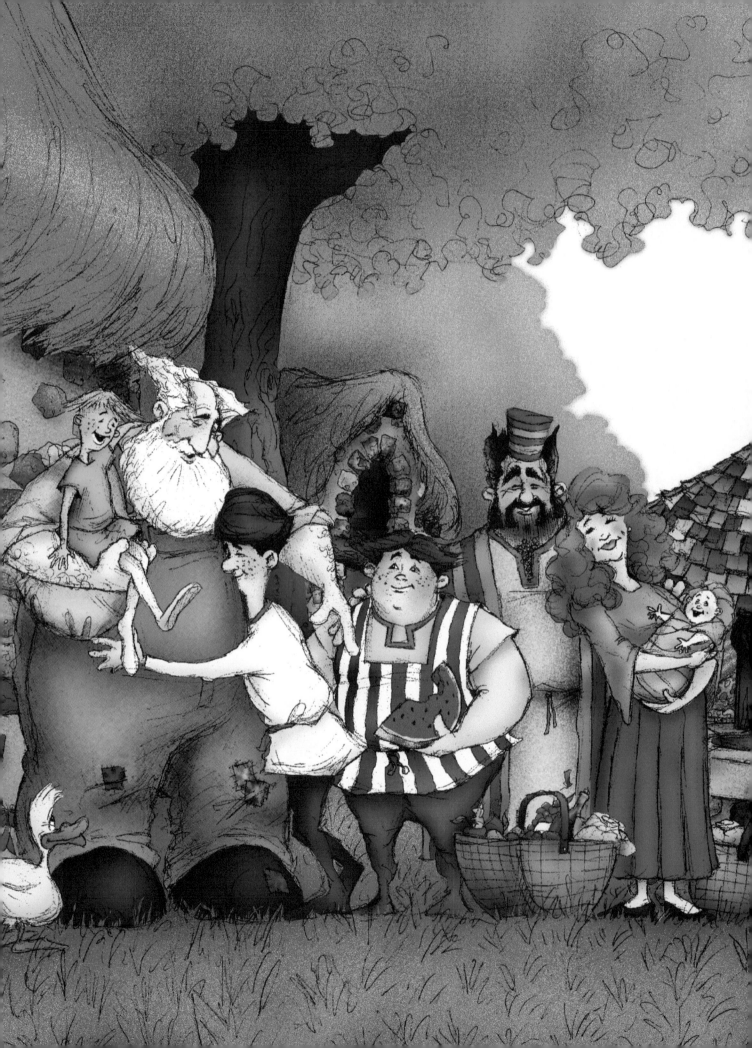

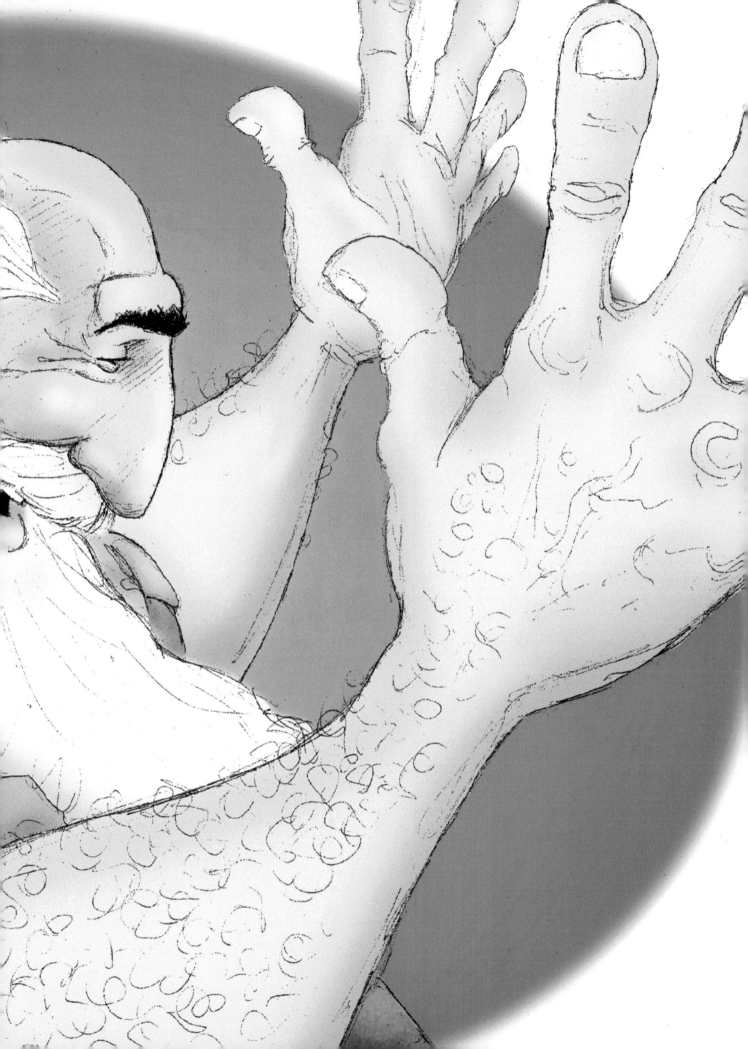

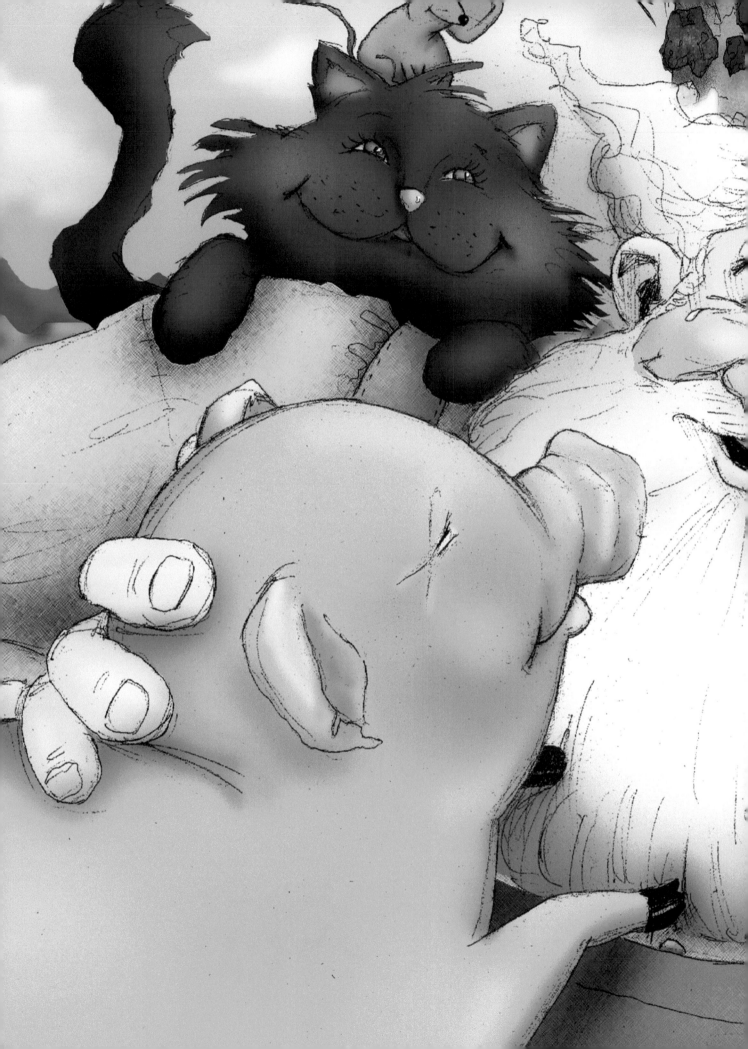

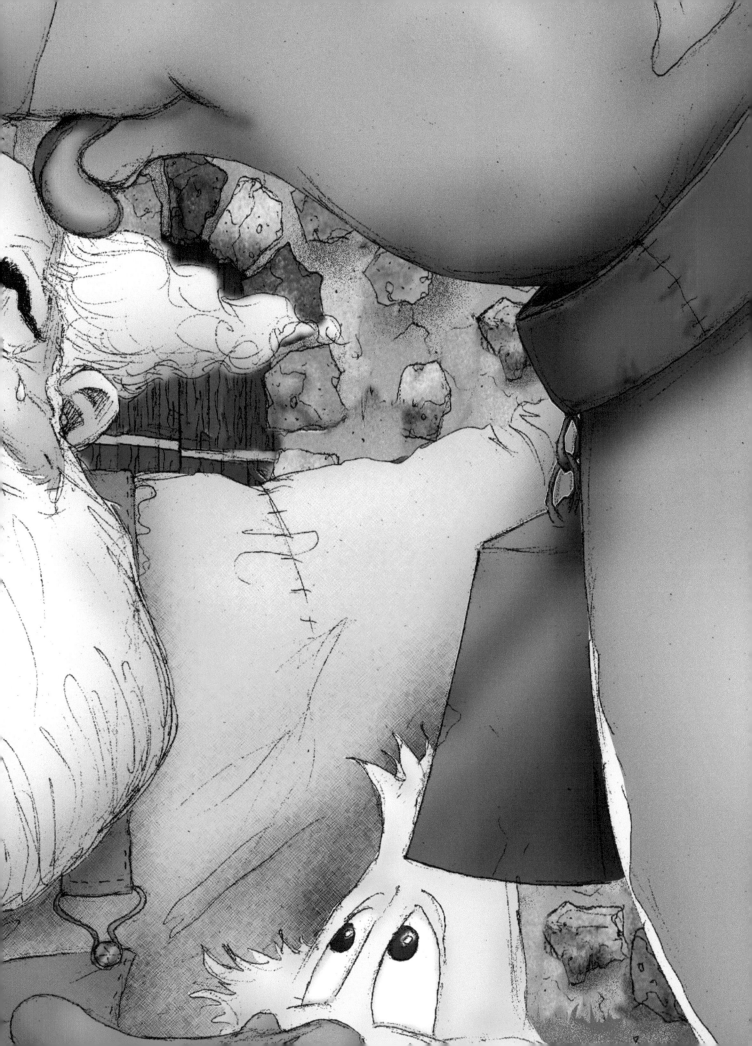

Mark Ludy has written and
illustrated a number
of books while being
a regular speaker.
His style is unique
with its whimsy and
detail that often pulls
upon the heart. He has
three children and a
wonderful wife. Follow
him and his work either
on FaceBook or at
MarkLudy.com.

Written and illustrated by Mark Ludy
Edited by Pat Brunner & Mark Rifkin

Scribble & Sons
www.GoodBookCo.com
info@GoodBookCo.com

Publisher's Cataloging-in-Publication
(Provided by Quality Books, inc.)

The Farmer / written and illustrated by Mark Ludy. --4th ed. p. cm.
Summary: After a tornado destroys his crops, a farmer must
sell his cow, and after neighbor boys burn his garden,
he must sell his beloved pig, but he never loses faith in God.
LCCN : 98-73805

ISBN-13: 978-0615933443
ISBN-10: 0615933440

Printed in USA

Special thanks to Jared, it was you who inspired this book. Paul, Sue, Eb, Deb, Steve and Susan, this book wouldn't have been completed without you.
Pat, you are amazing and so appreciated. And family, thank you for your support and love through the years. The beauty in this book reflects the beauty I've seen in your lives.
And Lord, truly its you who is worthy of all my gratitude. May I forever trust you as the Farmer did.

Other wonderful books by author/illustrator Mark Ludy

CPSIA information can be obtained
at www.ICGtesting.com
Printed in the USA
LVHW071310220221
679643LV00019B/70